OCCUPY

TRI⬤S

Each TRIOS book
addresses an important
theme in critical theory,
philosophy, or cultural
studies through three
extended essays written
in close collaboration by
leading scholars.

OCCUPY

THREE INQUIRIES IN DISOBEDIENCE

W. J. T.
Mitchell

BERNARD E.
Harcourt

MICHAEL
Taussig

A Critical Inquiry Book
The University of Chicago Press
Chicago and London

W. J. T. MITCHELL is the Gaylord Donnelley Distinguished Service Professor in the Department of English Language and Literature, the Department of Art History, and the College at the University of Chicago. He is the author, most recently, of *Cloning Terror: The War of Images, 9/11 to the Present*, published by the University of Chicago Press. He is also coeditor of the journal *Critical Inquiry*. BERNARD E. HARCOURT is chair of the Department of Political Science and the Julius Kreeger Professor of Law at the University of Chicago. He is the author, most recently, of *The Illusion of Free Markets: Punishment and the Myth of Natural Order*. MICHAEL TAUSSIG is the Class of 1933 Professor of Anthropology at Columbia University. He is the author, most recently, of *Beauty and the Beast*, published by the University of Chicago Press.

The University of Chicago Press, Chicago 60637
The University of Chicago Press, Ltd., London
© 2013 by The University of Chicago
All rights reserved. Published 2013.
Printed in the United States of America
Earlier versions of these essays first appeared in *Critical Inquiry* (Summer 2012).

22 21 20 19 18 17 16 15 14 13 1 2 3 4 5

ISBN-13: 978-0-226-04260-2 (cloth)
ISBN-13: 978-0-226-04274-9 (paper)
ISBN-13: 978-0-226-04288-6 (e-book)

Library of Congress Cataloging-in-Publication Data

Mitchell, W. J. T. (William John Thomas), 1942–
 Occupy : three inquiries in disobedience / W. J. T. Mitchell, Bernhard
 E. Harcourt, Michael Taussig.
 pages. cm.
 "A critical inquiry book."
 ISBN 978-0-226-04260-2 (alk. paper) — ISBN 978-0-226-04274-9 (pbk.
 alk. paper) — ISBN 978-0-226-04288-6 (e-book) 1. Protest movements. 2.
 Occupy movement. 3. Arab Spring, 2010– I. Harcourt, Bernhard E., 1963–
 II. Taussig, Michael T. III. Title.
 HM881.M585 2013
 322.4—dc23 2012043335

♾ This paper meets the requirements of ANSI/NISO Z39.48–1992 (Permanence of Paper).

CONTENTS

PREFACE

If journalism is the first draft of history, the following essays might be described as a stab at a second draft. This book is an attempt by three scholars from different disciplines, with sharply contrasting methodologies, to provide an account of the protest movements of 2011, from the Arab Spring to Occupy Wall Street. We deploy the perspectives of ethnography, political thought, and iconology in an effort to produce a multidimensional picture of this momentous year of revolutions, uprisings, mass demonstrations, and—most centrally—the *occupations* of public space by protest movements.

The structure of the book might be described as three concentric circles of history, moving from highly particular events in New York's Zuccotti Park to a more general reflection on the historic novelty of the Occupy movement in relation to the present state of American politics, and then to a global reflection on the role of media, images, and public space in the whole cycle of uprisings that spread like a virus across the Middle East to Europe, the United States, and beyond. Anthropologist Michael Taussig provides a thick description of the lived experience of Zuccotti Park—its scenes, sayings, and rituals. Political theorist Bernard Harcourt analyzes the refusal of Occupy movements to produce charismatic leaders and lists of demands as a form of "political disobedience" that goes beyond the tradition of civil disobedience. I discuss the role that images, media, and public spaces play in linking specific places and events to a larger sphere of global circulation.

As a totality, these essays aim to assess the precise character of a movement that is still in process and whose outcome is unclear. There will surely be third and fourth drafts to come, and surprises that cannot be anticipated. Nevertheless, it does seem useful to take stock and provide an account of the Occupy movement during a season of relative dormancy: the winter (2012) of discontent and quiet gestation, a time for winter soldiers, not sunshine patriots, to echo Thomas Paine. Revolutions have always been framed not only in terms of radically new turns in history, but also in images of return and the cycle of seasons. The Arab Spring, echoing no doubt the Prague Spring of 1968, provoked the Wisconsin Spring and the occupation of the state capitol in Madison. These spring uprisings were followed by the long hot English summer of rioting in London; the tent city encampment on Rothschild Boulevard in Tel Aviv; the violent suppression of uprisings in Syria, Yemen, and Bahrain; and an externally supported civil war in Libya. Occupy Wall Street, launched on September 17, 2011, constituted an "American Autumn" as protests spread from Zuccotti Park to scores of cities all over the United States.

The point of view of these essays might be described as hybrid, linking a sense of solidarity with the spirit of Occupy to the critical perspectives provided by well-established disciplines and professions: ethnography, law and political science, art history, and media studies. At the same time, each of these writers professes a more or less "disobedient" relation to the protocols of their disciplines. Taussig violates the supposedly scientific division between participant and observer that is fundamental to anthropology. Harcourt's work as an adviser and advocate for his students in Occupy Chicago complicates his role as a critical commentator who refuses to speak "for" or "to" Occupy in any representative capacity. My iconological approach requires a constant shuttling across the standard boundaries between art and mass culture, aesthetics and politics, witnessing and bearing witness. Situated at the border between commitment

and critical analysis, these essays were all written with a strong sense of the authors' limitations. None of us is qualified to speak with authority about the Middle East. Taken as a trio of well-established white American male scholars, we cannot claim to represent the diversity that constitutes the Occupy movement in the United States, much less globally. All of us would subscribe to Taussig's sense of humility in the face of Nietzsche's impossible demand "that a historian has to create a text equal to what he/she is writing about."[1] All of us would confess to Harcourt's sense that "our language has not yet caught up with the political phenomenon"[2] we are describing, while at the same time insisting with Taussig that "description and analysis of an event is a culture-creating activity" (Taussig). The authors might be called, as Harcourt suggests, "fellow travelers" who are skeptical that any ready-made "communist hypothesis" is adequate to the Occupy movement (Harcourt). At best, these essays hope to provide one more modest beginning, in Edward Said's sense of the word,[3] in understanding the momentous events that shook the world in 2011.

Indeed, the very notion of "the event" comes under scrutiny in these pages, which explore other ways of conceptualizing revolutionary processes. Would it be better, for instance, to think of this as a revolutionary *moment*, with all the associated ambiguities of the merely "momentary" and ephemeral alongside the sense of the *momentous* turning point, the "moment of force" that torques historical events and makes tiny occurrences (a fruit vendor's self-immolation in Tunisia, for example) into a global incident and a catalyst for revolution? Would it be better to think of revolutions not as specifically definable events, but instead as subtle shifts in language, imagery, and the limits of the thinkable? Could it be that 2011 is what Barack Obama has called a teachable moment, one in which the president of the United States, as sovereign pedagogue, learned from the Occupy movement how to speak a new, more emphatic language? How can one bring into focus both the multiplicity and the

unity of this remarkable year? What narrative would be adequate to it? Of course many narratives have already been tried out, and the op-ed pages and blogosphere have churned out millions of words to explain it. Each of these sites and actions is distinct: Tangier is not Cairo is not Damascus is not Tripoli is not Madison is not Wall Street is not Walla Walla, Washington. Each place has its own particular history and circumstances. And yet we know that something links these places and the events that transpired in them. In the nineteenth century we would have called it the spirit of revolution, and understood it as a kind of ghostly, uncanny return of familiar images of popular uprisings and mass movements—among these the ghost that was haunting Europe when Karl Marx and Friedrich Engels penned the *Communist Manifesto* in 1848. In our time the preferred language is biological and biopolitical, employing terms like "contagion" to describe images and words that have gone viral in the global media.

We also know that the spirit of the nineteenth-century revolutions was carried by very concrete and material forms of mediation, from the "unlicensed printing" of pamphlets to the brand new postal systems that made it possible for revolutionary "corresponding societies" to exploit the mass communications and social media networks of their day. Twitter, Facebook, text messaging, e-mail, and digital imaging provide the technical basis and open new media spaces for political assembly and contestation. A virtual and highly mediated "space of appearance" (to use Hannah Arendt's term) sprang up alongside new forms of *immediacy* in real places and times of face-to-face encounter[4]—the people's microphone and the drum circles of Zuccotti Park, the dancers and banners and posters of Tahrir Square, the mass encampments with their dispensaries of medicine, food, clothing, books, their working groups and general assemblies.

The Occupy movement presented, in short, a rebirth of the political (and the social) *as such*. At the heart of Occupy, whether

in Tahrir Square or Zuccotti Park, was not quite "politics," and certainly not politics as usual, but a reopening of what Hannah Arendt called

> the space of appearance [that] comes into being wherever men [and women] are together in the manner of speech and action, and therefore predates and precedes all formal constitution of the public realm. . . . Unlike the spaces which are the work of our hands, it does not survive the actuality of the movement which brought it into being, but disappears not only with the dispersal of men . . . but with the disappearance or arrest of the activities themselves. (Arendt)

The refusal of Occupy to designate leaders or representative spokespersons, its insistence on anonymity and equality, and its reluctance to issue a specific list of demands or policy recommendations was an effort to prolong this moment of rebirth and renewal of the political. It managed to dilate the period of what Arendt called "natality," the fact

> that men [and women] are equipped for the logically paradoxical task of making a new beginning because they themselves are new beginnings and hence beginners, that the very capacity for beginning is rooted in natality, in the fact that human beings appear in the world by virtue of birth.[5]

That is why weddings were celebrated and babies were born in Tahrir Square.[6] In contrast to the usual rituals of *demonstration*, which are by definition limited to a specific time and place, *occupation* is a form of expressive conduct that states a determination to remain and to dwell in the public space indefinitely. It was not that the occupiers needed a place to sleep, but that they were saying something by doing something, a neat reversal of speech act theory that focuses on saying as doing in performative utterances. When pundits and commentators insisted that

Occupy "state its demands," then, they missed the most important statement that was being made by the movement, the same statement that was made during the American civil rights era: "We shall not be moved." We are here, and are determined to dwell in this place as long as it takes.

As long as it takes to do what? Of course, numerous demands were issued, ranging from the removal of authoritarian governments in the Middle East to the transformation of political economies and the end of corruption in the United States and Europe. But an even more immediate performative goal was to make visible the massive and violent overreaction of the state to these rebirths of primitive democracy. Arendt notes the fragility of the space of appearance, the "disappearance or arrest of the activities themselves." And it was these moments of disappearance, eviction, dispersal, and arrest, often accompanied by excessive force and tactics of media censorship, that rendered hypervisible the response of threatened governmental authorities. The spectacles of violence, from the hired thugs who laid siege to Tahrir Square to the massacres perpetrated on the Syrian people to the clubbing, pepper-spraying, tear-gassing, and shooting of nonviolent protestors across the United States were also an essential part of the performative utterances of Occupy. Mayor Rahm Emanuel of Chicago, as Harcourt shows, rammed through legislation authorizing him to

> marshal and deputize—I kid you not—the United States Drug Enforcement Administration (DEA), the Federal Bureau of Investigation (FBI), the United States Department of Justice's Bureau of Alcohol, Tobacco, and Firearms (ATF), and the entire United States Department of Justice (DOJ)—as well as state police (the Illinois Department of State Police and the Illinois attorney general), county law enforcement (the state's attorney of Cook County), and any "other law enforcement agencies determined by the superintendent of police to be necessary for the fulfillment of law enforcement functions." (Harcourt)

Mayor Michael Bloomberg of New York City similarly played his part, mobilizing the New York Police Department, which he seems to regard as his personal army, to rout Occupy Wall Street from Zuccotti Park in the middle of the night while forcibly preventing journalists and cameras from recording the tactics of the police.[7]

These efforts to abort the birth of new spaces of democracy, while trampling all over the First Amendment "right of the people peaceably to assemble," were also statements of a clear message to potential occupiers: Spaces of actually existing democratic equality are a danger to the political status quo and will not be tolerated. In this sense, US mayors from New York to Oakland to Chicago managed to replay the role that Martin Luther King Jr. assigned to Bull Connor in Birmingham, Alabama, in 1963. The spectacle of police brutality, including the effort to cover up that spectacle, paradoxically has the effect of amplifying the message of Occupy, making its statements about the actual conditions of political and economic corruption even more emphatic and irrefutable.

What is next for Occupy? We are not prepared to make predictions. What does seem clear is that the movements of 2011 have changed the world in some fundamental ways. As revolutions, the events are so heterogeneous as to defy generalization. Some people are driven to violence by the intransigence and brutality of established authority; most are nonviolent and aim not at regime change but at a systematic overhaul of capitalism and its relation to democracy. Everyone agrees that Occupy Wall Street changed the conversation in the mass media from deficit reduction to economic inequality and joblessness. It may be that some of the revolutions have already done what they could, while others are in the process of being betrayed or suppressed. Meanwhile, something has been born, or reborn, in occupied spaces from Tahrir Square to Zuccotti Park, and we now must wait to see whether it will be strangled in its cradle. We know one thing for certain: the meaning of the word and

image of "Occupy" has been irrevocably changed. A transitive verb that can take an indefinite range of objects has now become a noun and an adjective and an iconic brand name as well, performing as the subject as well as the predicate of expressive conduct and action-as-speech. Occupy has also reversed the meaning of the notorious contemporary image of the camp, exemplified by the detention center; the tent city, for so long the emblem of refugees and displaced persons, has been transformed into a site of gathering resistance. Occupations of large civilian populations and territories by military administrations in Iraq, Afghanistan, and Israel-Palestine now must face their positive counterparts in the form of democratic occupations that promise to bring something new into the world.

W. J. T. Mitchell

NOTES

1. Michael Taussig, "I'm So Angry I Made a Sign," in this volume.

2. Bernard E. Harcourt, "Political Disobedience," in this volume.

3. See Edward W. Said, *Beginnings: Intention and Method* (New York: Basic Books, 1975).

4. Hannah Arendt, *The Human Condition* (Chicago: University of Chicago Press, 1958; Second Edition, 1998), 199.

5. Hannah Arendt, *On Revolution* (1963; New York: Penguin, 2006), 203.

6. "It's not just revolutions that see the light of day in Egypt's squares. Tahrir News reports that a protester gave birth today in Tahrir Square. She was rushed to an ambulance where she delivered her baby" ("Massive Number of Egyptians Take to Streets on Jan 25 Revolution Anniversary," *Ahram Online*, January 25, 2012, http://english.ahram.org.eg/NewsContent/1/114/32651/Egypt/-Jan-

uary-Revolution-continues/Massive-number-of-Egyptians-take-
to-streets-on—Ja.aspx).

7. See Alex Pareene, "Mayor Bloomberg's Army," *Salon,* Decem-
ber 1, 2011. Accessed at http://www.salon.com/2011/12/01/mayor_
bloombergs_army/.

OCCUPY

I'M SO ANGRY I MADE A SIGN[1]

Michael Taussig

A NOTE ON FORM

I have inserted the signs in Zuccotti Park as set-apart quotations in the center of the page. And sometimes I have also inserted quotes from texts by philosophers, poets, and other people worth listening to. They, too, look like signs. I don't think you will confuse them, but it's better if you do.

A NOTE ON STRATEGY

Nietzsche says somewhere that a historian has to create a text equal to what is being written about. This would seem especially compelling when it comes to Occupy Wall Street.

In *The Gay Science*, Nietzsche has a paragraph, "To Destroy Only as Creators," which I take to mean a demand not for "positive critique," but that we be aware of how description and analysis of an event is a culture-creating activity, and write accordingly.

Coming back to this text of mine six months after it was written is like visiting a strange and fabulous land. I imagine it will be the same for you.

> *Wall St is everywhere*
> *therefore we have to occupy everywhere*

11:00 P.M., OCTOBER 13, 2011

On my way downtown to Occupy Wall Street, Zuccotti Park, New York City. Flustered and excited. E-mails coming in from Yesenia, and from Michelle and Alex in my sorcery and magic class at Columbia. They should be writing their weekly assignments for school. They are so far behind. But this is the night the mayor will attack. I stop by the bagel store to tell this to my Mexican friend who serves behind the counter. He is counting money and is preoccupied. He has never heard of OWS and he tries to look interested. My canvas bag is stuffed with sleeping bags for Saa and myself. Long wait for the #1 train. Unbearable. Alex says rumors of police closing in at midnight. Danny Alonso, also in my sorcery class, once compared visiting Zuccotti Park—which he did all the time from day one—to the excitement of going to the movies and getting into the trance of that other reality. You get hooked, he later wrote. "I would be hypnotized and turned into someone else." In fact, many selves. A drumming self. A facilitator self. A hunting and gathering self roaming Manhattan for tarpaulins and food from dumpsters to bring the tribe, listening to stories "and healing from people who had come from all over to share in this moment." Many of these people had lost their jobs.

Lost my job but found an occupation

You break through the screen, like Alice in Wonderland. And now you can't leave or do without it. Everything else seems fake and boring. So how do you write about it? In such circumstances of dissolving norms, effervescent atmosphere, invention and reinvention, what happens to the ethnographer's magic—as Malinowski called it—and that old standby of "participant observation?"

And is the magic strong enough?

Am I clear here? I don't think so, and I think this is the problem of writing surprise and writing strangeness, surely the dilemma and sine qua non of ethnography? As soon as you write surprise—or, rather, attempt to write it—it is as if the surprise has been made digestible so it is no longer surprising, no longer strange. To "occupy ethnography" is to get around that somehow, to seize on the means and manner of representation as estranged. An exuberant style is not enough. That is why I so much like the zombie-style bodies and faces of the sign holders who populate Zuccotti Park, graven images outside time.

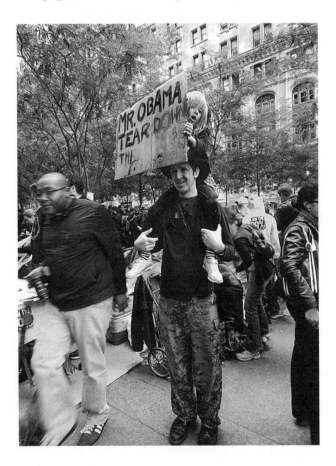

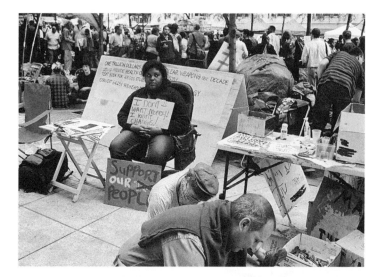

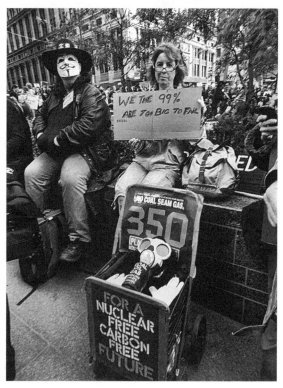

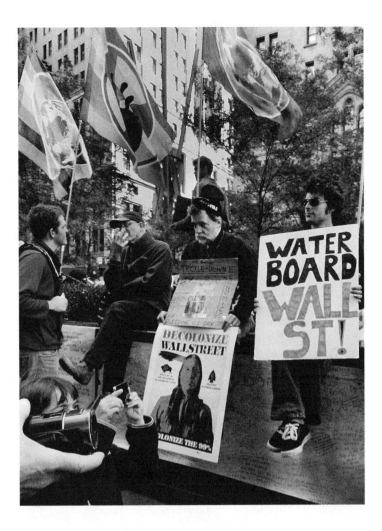

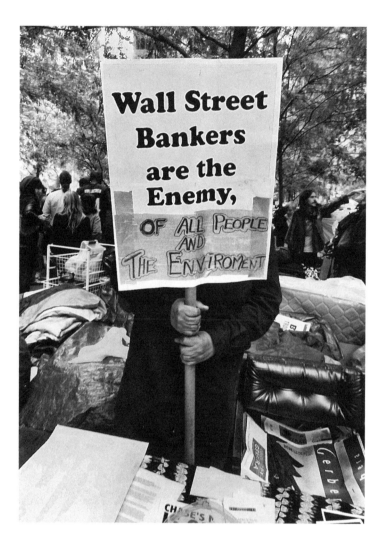

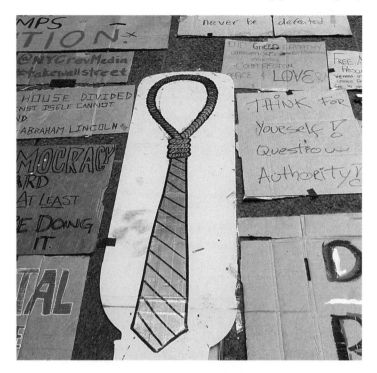

Welcome to Hakim Bey's Temporary Autonomous Zone. I recall Paris, May 1968: people said they lived in that zone for months, didn't sleep, didn't need to. Out of nowhere a community forms, fueled by the unforeseen chance to fight back. Decades drift away. Decades of Fox News and Goldman Sachs. Decades of gutting what was left of the social contract. Decades in which kids came to think being a banker was sexy. When that happens, you *know* it's all over—or about to explode, as once again history throws a curveball. Once in a lifetime, the unpredictable occurs and reality gets redefined.

The most striking sign I have seen at Zuccotti Park over three months was a life-size painting of a man's striped tie on a white background. The tie was knotted to form a circle at the top like a hangman's noose. Wordless. Next to it was a sign with blotchy patches of white over some of the letters:

**They piss on us and call
it trickle down**

America wakes up from the American Dream. "I've been waiting for this all my life," says Craig, who stayed with me overnight from California with naught but a backpack on his way to Zuccotti Park.

**I awoke in a sweat
from the American Dream**

"At night we lie all together on the concrete," writes Alex, "a few sleeping, the rest talking in low voices, or reading next to the street lights, or cursing the constant sirens that we are certain the NYPD sends around the park at night just to keep us poorly rested and easily dominated, or looking through the thin canopy of leaves between the dark towers and the sky. The first morning we all agreed that we felt as if those buildings would fall in on us.

"Dear WB," she goes on, "maybe OWS is something like that awakening that is between sleep and consciousness. We are emerging from slumber but we are disoriented, stupored, caught between the dream logic of capitalism and the newly forming world."

"Dear WB." How blessed is that? She is writing code, of course—direct from the state of emergency. She is searching the zone of the dialectical image that Walter Benjamin envisaged as emerging from the dream sleep of capitalism that reactivated mythic powers. Just as one swims in the surreal zone of semisleep as harbinger of revolution, so does the epoch. Does the new security state understand and believe this too, along with

Walter? Why else would they walk silently through the park at night, filming the sleepers?

**you must be asleep to experience
the American Dream**

Salomeya put it a little differently. She has a theory, as usual. Working out of the sense of the body and magic she finds in Malinowski's discussions of clan and sub-clan solidarity and sorcery, she discerns a form of human bonding relevant to OWS that she calls "erotic materialism." It is a brilliant rereading of classical anthropology applied as much to Zuccotti Park as to aforesaid dream sleep mythology. (Now she tells me she suffers from being too abstract, but there's little she can do about it.)

But the lines get blurred. Solidarity gets tested. As time goes by, it is said that undercover police roam the park disguised as protesters. (Question: What does a protester look like?) It is said that homeless people are being directed by the police and shelters to go to Zuccotti Park in the hope that they will dilute and factionalize the occupation. The ideals of the radical hipsters from Brooklyn with their web-savvy culture are being tested like never before by these homeless men who seem uninterested in what the hipsters stand for, yet the whole point of OWS is homelessness. As time goes by—horror of horrors!—something like property and real estate interests surface. Someone quips that there is an Upper East Side section of tents in the park, and one hears muttering of gentrification, as if this utopic space is reproducing what it is against.

**We just bought real estate
in your mind**

It is said that there are rapes and stealing, and there certainly is stealing. Craig got all his stuff swiped after he left for half an hour to wash up in the bathroom of Trinity Church.

**I can hire one half of the
working class
to kill the other
Jay Gould**

I walk out of the subway at Fulton Street into the canyons of Wall Street, Fritz Lang's Metropolis of soaring towers holding up a black sky heavy with rain clouds, workers in cages like moles—no speech (1927), only cryptic subtitles and madly gesticulating figures with pasty white expressionist faces caught in frozen grimace. Police cars and vans are everywhere around the park and secreted in back alleys.

Down on the ground it is a war zone crackling with expectancy. But overhead, Freedom Tower, sheathed in mirrors, dwarfs everything, glistening with blue light. What did Benjamin say in "This Space for Rent" in *One Way Street*, that other OWS published as the fuse was being lit in Europe, in 1928, one year after *Metropolis*:

**What, in the end, makes advertisements
superior to criticism? Not what the
moving red neon says—but the fiery
pool reflecting it in the asphalt**

You take a deep breath when you get there, and you can't breathe again until you leave. It is devastatingly spectacular and

inhuman: the architecture of what Marx called M-M', meaning money making money, meaning finance capital, of which credit default swaps are the ultimate expression of the moneylenders Christ drove from the temple.

Is this what occupation of the park means—a moral movement against the exploitation of people not only by the moneylenders, but by the apparently neutral means of money doing

it all on its own, meaning M-M'? Does the occupation occupy the magical energy of this fetish, and from this abundant source draw its energy? Wall Street is forbiddingly allegorical. Fritz Lang provides a frightening topography of heaven and hell, of our Metropolis. But, closer to home, so did Diego Rivera in 1931, during the Great Depression, with his painting *Fondos Congelados* (Frozen Assets), showing the serene temples of Manhattan as an archaelogical stratum atop a dimly lit subterranean morgue with corpses laid out in rows, supervised by a lonely guard. Perhaps they are not corpses, you say to yourself, but merely sleeping bodies. These are the "frozen assets": the unemployed laid out like corpses in prisonlike dwellings, bringing to mind the notion of capital as "congealed labor." It is a terrible picture. You could hear a pin drop.

But now, miraculously, with the occupation in full swing, the picture had come alive as the architecture of M-M' lost its grip. We looked at each other eye-to-eye in those days, never quite knowing what the next enchanted moment would bring. We were bigger than the buildings, and instead of being physically compressed and mentally scripted, like the poor bastards in the offices all around us, we lived moment by moment, sparks flying from a knife grinder's wheel.

Even if Zuccotti was barren in winter as I wrote this, rarely did a day pass without mention in the media of OWS or the huge gap between the rich and the rest. The day I passed Zuccotti Park in mid-January, the mothers of girls in private schools of the Upper East Side, like Spence and Brearley, were reported in the *New York Times* as bemoaning the fact that, for the first time ever, their daughters had not gotten into Yale on early admission. Was that because of anger at the 1 percent? they wondered. That same day I passed a hole-in-the-wall restaurant uptown on Amsterdam Avenue and 102nd Street called Busters of New York. On a blackboard outside was displayed its menu:

Wrap: "Occupy the Dream"

Down the street from Zuccotti Park, the Museum of the American Indian. Right by the park, an African slave burial ground. How extraordinary! And right here in Zuccotti Park, many black protesters. But amid the hustle and bustle of the streets, does anyone notice that the center of the world's money—what makes this city so "global"—rests on top of skeletons of African slaves and ghosts of Indians, no doubt shaking wampum and featherwork. It is all so arty now, like Julie Mehretu's gorgeous five-million-dollar, eighty-foot-long mural adorning the glass-walled lobby of the new Goldman Sachs building along the Hudson, not so far away. They so want art, the 1 percent. Man does not live by bread alone. And art is a great—many say the greatest—investment in these troubled times. Three days before the occupation is forcibly ended by the baton-wielding NYPD, art shows its power:

As Stocks Fall
Art Surges at a $315 Million Sale

*Despite (or perhaps because of) the stock market's nearly
400 point plunge on Wednesday, collectors on Wednesday night
raced to put their available cash–and lots of it—into art
(New York Times, November 10, 2011)*

But try to be a young artist impassioned by art—something you could die for—if you don't have a trust fund and your parents aren't rich with connections in the art world. I dare you. The humiliation. The slime. The eating away of self-confidence. Do anything, anything at all, to survive. The heart-rending questions: What is art? Why that, and not this?

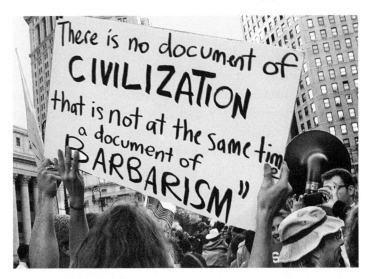

A little further uptown, where prostitutes practiced their art and hoary truckers got laid, where the smell of rancid fat from the meat packing district used to be, now you have the lovely "high line" of swaying grasses along the abandoned railway tracks, the capstone of gentrification from which you can peer down into boutique stores and forget that Manhattan has become unlivable for most people. What are all those smart people talking about in those chic restaurants? "Ultimately what Zuccotti Park is all about," Reinhold tells me (and he should know, urban planner that he is), "is real estate." What he means is that the occupation is testing the limits of monetarized space. So what we have is

real estate
finance capital
art
and now OWS (another form of art)

Man does not live by bread alone. They so need art, the 1 percent. *But so does OWS.* This is not only a struggle about income

disparity and corporate control of democracy. It is about the practice of art, too, including the art of being alive.

History congeals, then dissolves; and somehow art always ends up being art. When some OWS-inspired people dropped a banner inside the Museum of Modern Art in support of the art handlers locked out of Sotheby's, MOMA people quickly appropriated the banner as art.

History congeals, then dissolves. The chiseled stone of the older Wall Street buildings gives way to mirrored buildings fighting free of history on postmodern wings. Money helps. Night and day, the crescendo of jackhammers obliterates time itself. Cranes lace the sky, adding new constellations. "All that is solid melts into air." *The Communist Manifesto.* Marshall Berman, "the bourgeoisie has a vested interest in destruction." But one day it will go too far. Marx and the Wobblies, giving birth to the new society in the womb of the old. Dreams of the classless society. Tomb and womb. Space of death. Indians with the ghost dance. Starting up again. "Fellow slave" is how the Wobblies addressed each other. Fellow slave. A sign on the pavement:

**Nobody is more hopelessly enslaved than
those who believe they are free**

I look in heaps of garbage for plastic bags to cover us if we try to get some sleep. Huge white plastic bags outside Starbucks look usable. Homeless woman asleep in a doorway, wrapped in a enormous black plastic bag. Right idea. Slight drizzle. Warm. Get to the park. A crazy-looking guy walks by with a sign:

**We are the future
We are going to win**

He is dragging a white dog. He is ready to fight, but his forked fingers mean peace. Some people are ripping open plastic bags. The "human microphone," which everyone spells as "mic check" but is pronounced "mike check," is in full swing, explaining civil disobedience and what to do when arrested. I hook up with my students and with Saa. Magic markers are passed around, for writing the telephone number of the Lawyers' Guild on one's skin. Rain is getting heavier. We are being encouraged to clean the park, which seems absurd to me, because that validates the mayor's excuse for dealing with protesters, as vermin that need extermination . . . time and again, the unclean, the disorderly, the un-uniformed, the un-uniform. And let's not forget the worst, the anarchists, as much vilified by the police as by Marx and Engels.

**We all know
where the real dirt is**

"It has to be cleaned up," the "chief executive" (note the nomenclature) of the management company overseeing the park is reported as saying. The billionaire mayor's girlfriend is on the board of the company that owns the park, and the mayor (according to the *New York Times*, October 15, 2011) "is a mayor obsessed with the cleanliness of the city's public spaces." Later we hear that the management company is way behind in paying its taxes to the city. There are brooms and soap galore, and here I am with a broom, side-by-side with a merry fellow in a Santa Claus outfit leading the crew. A woman starts up a mic check.

Hello
Hello

I am the sanitation group

I am the sanitation group

(Her voice is shrill, authoritative, nagging)

I am not *the* leader
I am not *the* leader

(long pause)

I am *a* leader
I am *a* leader

The park slopes downhill to the west. Rivers of soapsuds float west merrily along with Santa. Saa loves to clean, and is doing a great job. It feels good to be doing something physical. There are many brooms, all new. No shortage of stuff in Zuccotti Park. This place is organized! Check out the People's Library, the kitchen, The Poets' Corner, the drummers, and the altar. But no time for that now. We are in lockdown, as if a hurricane is imminent. The three thousand or more library books are lovingly bundled into plastic boxes. Together with the poets, the books are the "crown jewels" of this liberated zone, this experiment in "horizontal" decision-making and vertiginous imagination. When the occupation is finally and spectacularly smashed a month later, during the night of November 15, with riot police beating up protesters and journalists alike, and the night sky humming with police helicopters, the books are thrown into garbage cans and taken away, supposedly to the sanitation garage on 57th Street. Can you imagine! *Sanitation* for books! (And why can't they say *garbage* in this country?) Not to worry.

"Every morning before GA [the general assembly], we would gather on the street and start up the drums," says Danny. "Our efforts channeled the pulse of the occupation." On the first night of occupation he felt drawn to the group of people drumming, singing, and dancing. He had never thought of himself as a musician or a performer, but he felt compelled to pick up a small

drum. "As we share this warm harmony, " he later wrote, "I decide to burn some incense. It seems others had something similar in mind and soon we are enveloped in candles, smoke, and warmth. While many of us play, a few souls decide to stand up and channel the rhythms into song and rhyme. Out of nowhere these wonderful lyrics emerge full of love, dreams, and longing for the moment of revolution. The space upon which we play is consecrated and transformed."

Next day, the people in the park invented mic check, originally "the people's microphone"—and Danny found himself facilitating the speakers through the process that has come to be called "stacking," whereby your eye is caught by someone in the crowd and you place them on the list. You learn the hand signals quickly down there, and invent just as quickly. Like the mic check, these signals bear the mark of an exotic tribe and secret society, invented yesterday, brushing history against the grain.

It is said that the mic check was invented because of the city ban on microphones in Zuccotti Park. That ban triggered the most powerful invention of the Occupy movement.

Seven months later in Union Square, at the New York May Day march, I saw many of the people who had been in Zuccotti Park, but this time there was something wrong. Instead of the magic of the mic check, there was a powerful public address system dominated by one or two people screaming slogans. There was little chance for the rest of us to converse with each other. The casual atmosphere was gone, as was the chance to hear opposing points of view enjoined by the crowd repeating the speaker as with the mic check. In that situation you rarely felt you were being screamed at or lectured. The easiest way to kill the Occupy movement would be with a centralized public address system, as opposed to the rippling network of wildlife that was Zuccotti.

The weather was unusually balmy in Zuccotti Park in September and October. To visit the park was like going to a street fair.

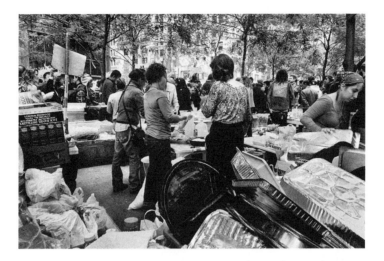

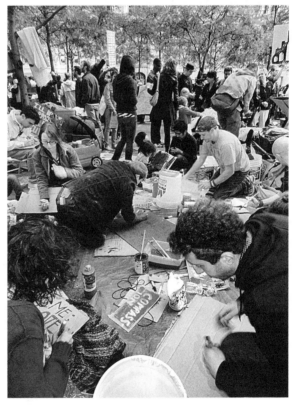

There were so many smiling, radiant people, mixed with a few grim, concentrated ones. Some women were topless. Many people were on their hands and knees making signs on brown cardboard recycled from boxes. T-shirts were being silk-screened. As the days went by, older people got into the mix. On the pavement by the park, tourist photographers stood three deep, many engaged in polite but strenuous political, philosophical, and theological debate.

Mutual responsibility
Come chat with us

The park was ablaze with flags: rainbows, the planet earth, and of course Old Glory with the logos of corporations instead of stars. Poor stars, trumped like this. But the trees still had their leaves, fluttering.

Most of all, I was struck by the statuesque quality of many of the people holding up their handmade signs: like centaurs, half-person, half-sign. Looking now at the photographs, which

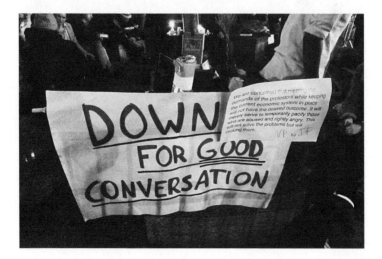

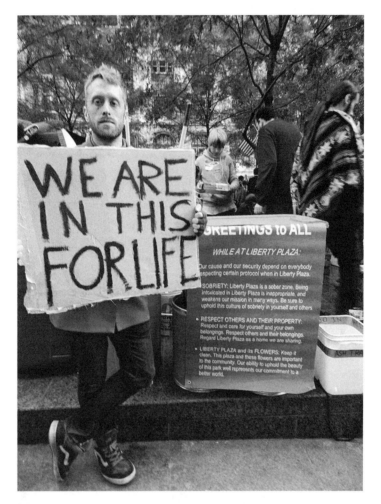

give me some distance from the hurly-burly of the face-to-face realities, I see the sign as an extension of the human figure, that history is being made by this stiller-than-still conjunction, heavy with the weight of ages and the exhilaration of bucking the system. And then I realize that this centaur-like quality and stiller than stillness—this terrible gravitas—occurs because the sign holder is posing for photographers, or rather, because the sign is being made to pose for the camera with its very stillness

calling to mind—for the aficionados, at least—that wonderful line of Adorno's in which he tells us that the trick to Benjamin's style is the need to become a thing in order to break the magic spell of things. Compare the statuesque quality of the centaurs with the radiance of the sign come alive.

It is the handmadeness of the signs, their artisanal crudity, art before the age of mechanical and digital reproduction, that facilitates this hop, skip, and jump. To Nancy Goldring, who took many of the photographs accompanying this essay, it

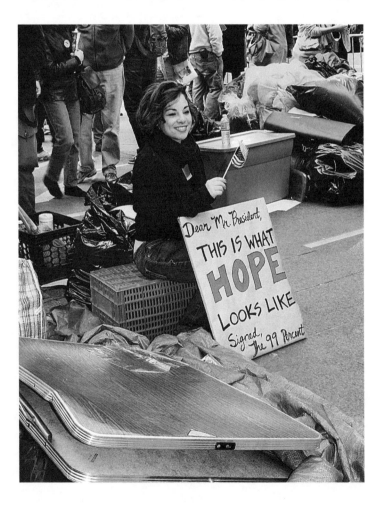

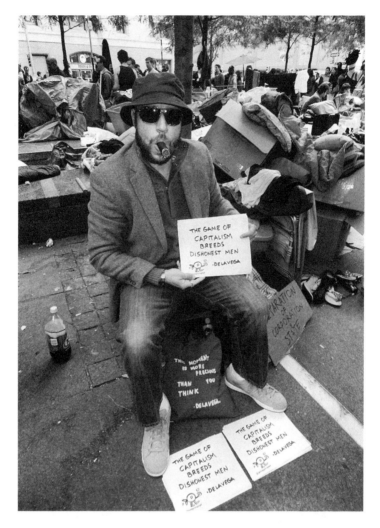

seems as if this graven quality comes from the sign saying exactly what the sign bearer wants to say. Put another way, the sign has a talismanic function, an incantatory drive, and is of divine inspiration, the gods in this case being of mirthful disposition, feeling quite at home in the park.

For a century now, advertising signs and images have stolen from the avant-garde. Now it's payback.

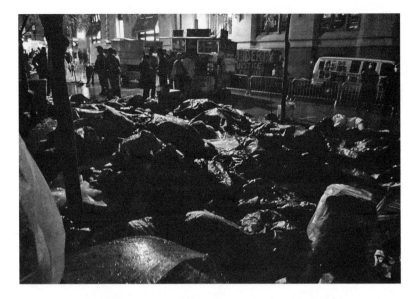

And here we are on the night of October 13, when the city is going to bring in its sanitation workers, backed by police. The tents have come down.

The park has become a sea of blue tarpaulins glistening with rain, a sea of hope. Is this the sea that Mao talked about in his writings on guerrilla warfare? Are we the waves to which Nietzsche passionately refers in his "Will and Wave," that mighty turbulence breaking on the rocks of time, dashing pearls, holding court with history through secret affinities?

That is how the waves live—
that is how we live,
we who will—I will say no more

Zuccotti Park is all that, bathed in an unearthly yellow-green light coming from the streets around. Underneath, hard granite. And underneath that? The beach!

**Truly, at this moment nothing
remains of the world but green
dusk and green thunderbolts**

Like dancers we swirl, floating on high spirits and the sense, no matter how silly, that at least we are accomplishing something by cleaning. Some socks float by. There is a smell of sage burning. Shamans circle the perimeter of the park providing the real cleansing. Scrub away. How absurd!

We use our magic to thwart their magic. They have pepper spray. We have burning sage. They prohibit microphones. We have the people's microphone. They prohibit tents. We improvise tents that are not tents but what nomads used before North Face. They build buildings higher than Egyptian pyramids, but that allows our drumming to reverberate all the louder and our projections of images and e-mails at night to be all the more visible and magical, taking advantage of the megascreens that the facades of these giant buildings provide.

Each day, each week, sees another deterritorialization of their reterritorializatons. They prohibit the electric generators we use for our computers and cell phones. We set up bicycles that can generate power, and people who would otherwise gawk and take photographs get into the movement; they become Dionysian and not just Apollonian, sitting in the saddle and pedaling like crazy. This is how they get into the movement. One woman sees it in historical terms, running in matrilines. As she pedals, smiling, she says, "I can tell my grandchildren I provided energy for Occupy Wall Street."

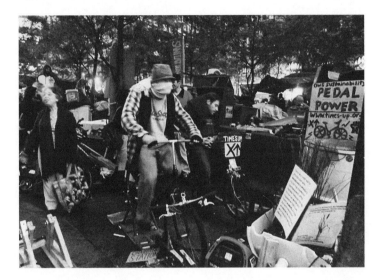

By her side, several older women sit sedate in lounge chairs knitting woolies for OWS and the coming winter. They have all the time in the world, for they inhabit time and time stands still. They don't need to reference history or the matriline. They are all that with what Benjamin called "the time of the now," that compressed stasis which is the revolutionary moment. Clickety-clack go the knitting needles as history is rewoven. They have cardboard signs by their sides, voicing their outrage. Clickety-clack. This is not the clickety-clack of the locomotive of history

which Marx invokes in his preface to *The Introduction to The Critique of Political Economy*. This is not the clickety-clack of Benjamin in his anarchist (Blanqui) mode, trying to figure out when to pull the emergency brake that will usher in the revolution. Nor is it the explosion that Benjamin invokes as the blasting apart of the continuum of history that creates the *jetztzeit*, the "time filled with the presence of the now." Revolution is different now.

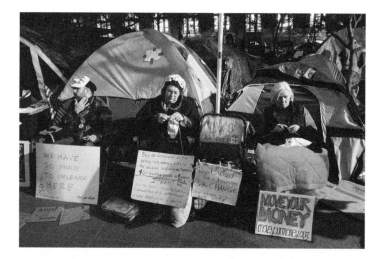

Another vision of revolution surfaces: a cheeky little 4×3" sticker adorning the seventy-foot-high orange metal *Joie de Vivre* sculpture at the southeast corner of the park:

Lick my
Goldman
Sachs!

Jack the giant-killer! This little fellow transforms the sculpture, another of New York's notable contributions to public art, but that is nothing compared with what has been going on in

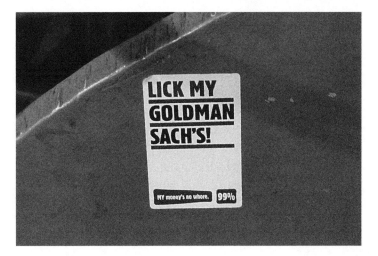

the park since OWS, where art acquires new meaning as we read
here:

**This
revolution for
display
purposes
only**

In the corner of the diminutive sticker, we read:

My money's no whore 99%

On all sides jackhammers, police sirens, and traffic roaring
down Broadway, echoes bouncing off buildings. Mic check and
the poets keep at it, along with the drums. Mic check: I still can't
get over this crazy spelling, a code for the initiated. An assault

on the signifier. My own name sometimes gets spelled thus: Mic. So what? Mick check? What is being checked here, anyway? A mic check is a check to ensure that an electronic sound system is functioning. *Doesn't matter what the sound is. Right?* Or rather, that the channel is open to all sounds. Everyone can have a shot. If anything is emblematic of the movement, this is it. And what of the marvelous paradox that this was invented in Zuccotti Park because microphones are banned by law! Inadvertently, what we can call "the system," the nervously nervous nervous system (which is also the blue tarpaulin sea), spun Hegel off his feet and gave the dialectic of history another twist, converting the state prohibition into a magical weapon that is now being copied across the country, if not the world, as a new form of social speech, a new form of being. Michelle tells me that even the police tried to use it once—at the end of the #3 subway line at New Lots, where OWS occupied a foreclosed home. Everyone laughs.

I think they got it wrong. We've been occupied for years. This occupation is de-occupation

And why magic? Because of the repetition? In repetition you come to grips with trauma, as will be recognized by readers of "Beyond the Pleasure Principle," a text that in Zuccotti, with "mic check," becomes a living text better called "Beyond 'Beyond the Pleasure Principle,'" since here death and pleasure commingle in the exploration of the creative effect of shock in modernity, there being different types of shock at work in OWS.

The shock of the system imploding (depression/ recession) is one of these shocks. The shock of mounting a challenge (OWS) is quite another, and both types of shock galvanize body and imagination. Shock speeds things up faster than light, but it also slows time down to dead crawl. This is the essence of Zuccotti as

people invent new ways of being, new ways of talking to one another. This is what makes for the "trance" Danny talked about. But it is also an awakening.

"Beyond the Pleasure Principle" is an essay that starts with shock and ends with the psyche become inorganic matter. History becomes natural history, yet natural history carries its own cosmic charge, as when the tides turn with the ascent of the moon and the sorcerer's spell gains momentum with song. And what of the driving storm tonight, the clashing elements as the mayor prepares his NYPD! For what is the death drive but a marvelous giving up, a succumbing—all that negativity which our culture tells us is wrongheaded and unhelpful—yet it is surely part of the libidinal energy that goes into this rebellion against money (see Norman O. Brown, *Life against Death*)? This is the physicality of the natural history at work in Zuccotti Park, the secret of what Salomeya calls "erotic materialism."

And why magic? Because with mic check, the rhetorical style alters towards the fundamental, the pithy, and the word jab. These are shocks too. These are drumbeats of words like the drums that keep going at the west side of the park, where what people call "the right brain" functions in contrast and as complementary to "the left brain" on the east side of the park (the higher side, of course), where mic checkers get their chance, and where the "general assemblies" take place every day.

And why magic? Because there is a religious wave, an African and/or African-American thing going on here, with the repetition of the pastor's words by the listeners, who are plural. We hear together. We repeat together. And in that repetition we first hear, then speak, thereby tasting the words in our mouths like cherries, with time to let the ideas settle. The idea part of the spoken word gets its chance to resonate in different dimensions of thought and of feeling.

There can be fear here, too: fear of mindless repetition of the brainwashed. This is the cultic expression of magic. But then the next mic checker gets up, and the message is quite different from

the last one! We repeat, yet we transform. And think of Allen Ginsberg with his harmonium and his *OOM, OOM*, and many more *OOM*s. There is joy in spoofing the too-serious ones, left-wing or right-wing, who assume they are the ones who know and have come here to tell us what's what. Remember Debs, the ultimate seduction? "I will not lead you into the Promised Land because if I do, others can lead you out."

This is worth thinking about. Occupying Wall Street inevitably means occupying how we talk in public, how we learn and teach, and how we write ethnography (about our own tribe). All this is up for grabs. Otherwise there is no occupation.

The occupation is self-reflexive to a fault.

True. But we are also the nervy nervous ones awaiting attack. In the wan, green light our sea ripples over the shoals of the nervous system. We are awaiting the police, who at the moment form a blue cordon around two sides of the park. On the north side their blue-and-white cars and vans face us, ready to leap. Behind the cars stands a skyscraper crisscrossed by dark steel beams, like a fortress. An art student from Parsons tells me it is the FBI building. In bold black letters on the facade, as I recall:

One Liberty Plaza

By 2 a.m. it is pouring. There is lightning and thunder. The heavens erupt. Reality mimics art, by which I mean John Cage's 1976 performance *Lecture on the Weather*, in which art mimics reality, the reality of storm. Cage devised this performance for the Canadian Broadcasting Corporation, to mark the US bicentenary. Twelve speakers recite different passages selected by chance from Thoreau's *Civil Disobedience*, all at the same time, until, about half an hour later, with a swelling hubbub of voices, lightning flashes and thunderclaps bring history and natural history together.

The crowd has thinned. The commercial food stands on the south side of the park are doing a great business. Their warmth, light, and sense of bounty are cheering. I meet up with students from Columbia. We mix and mingle, talking, smoking, animated, searching for shelter, waiting for the bust, scenarios of the impending attack running through our minds. Many people prefer to stand, shifting from one foot to another, finding friends, meeting strangers, forming a strange new community of the righteous and the beleagured. Classic concepts leap to mind—especially the "liminal space" Victor Turner illuminated for us from his studies in southern Africa in the 1950s, where the initiates were gathered and transformed step by step through rituals and symbols resonant with myth. Being betwixt and between, the initiates occupy a magical space in which the elementary forms of religious life take fire. The twin poles of birth and death frame the space. Womb and tomb.

"I asked my friend why he always wears that scarf," says Danny. "He's wearing the scarf that he wore on the first night of the occupation. I ask him why he always carries that scarf around him wherever he goes. He tells me it's like his baby blanket. 'On September 17 I died. On September 17 I began living. I found this scarf that day. It is a relic from the rebirth, from the moment when I started taking my first steps in this new life, in this new me.'"

Tomb and womb. A child is born from the womb just as spirits emerge from the tomb. *Emergence* is the trope. Emergence from the underworld. Orpheus, don't look back! Not this time! Sing your songs so beautiful they enchant animals and things such as these buildings reaching the sky, this Wall Street so mythical and world-dominating. "Mr. Gorbachev, tear down this wall," said the Great Communicator.

But what have we here? Weeks later, I see a photograph of a tall young man with camouflage pants, a black cowboy hat, and a big smile. He is standing on the perimeter of the park along Broadway, with a young girl on his shoulders who is holding up

a sign. Her mouth is wide open. Is it surprise? Is she challenging us? As always, the faces of the people holding the signs say as much as the signs themselves, and the signs say plenty. What is she holding up?

**Mr. Obama
tear down
this wall**

Looking for a new language? Well, here it is: the language of the sign, the language of wit rearranging history through a barrage of A- Effekts that warp what we have taken for real. It is a scene-language, like that on Brecht's placards hung above the stage. "Mr. Obama, tear down this wall!"

**I'm so angry that
I made a sign**

There is no doubt a morality play is taking place here, powered by the "moral economy" that the historian E. P. Thompson brought to our attention. This is even bigger than terms like "growing income disparity" or "We are the 99 percent" convey—terms encumbered by the same economism they challenge. "The rupture between bodies and homes, the rupture of foreclosure," writes Michelle, whose own family was foreclosed in Los Angeles, "is revelatory—spirits of home emerge as well as the specters of power. The taking of a home by a bank is experienced as a violation of sacred space." Thompson analyzed eighteenth-century bread riots in London. Today it's homes.

The Global City we hear so much about gets its comeuppance. There was the rancor of 9/11 as the empire struck back

a few blocks from here. And ten years later, there was Tahrir Square, downtown Cairo. Peter Lamborn Wilson put his pen and paints to work to make a poster which on April 20, 2011, he mailed from Cairo, a lamentably poor town in upstate New York. He mailed copies to the Gallery of the Surrealist Movement in Cairo, to the Egyptian National Museum, and to Egyptians in the United States, asking them to send it on to friends in Cairo. He also mailed a few to people like me.

Wake up America
Be like Egypt
Fatimid Order of Cairo, NY, greets Cairo,
Egypt, Tahrir Square
Overthrow all pharaohs
Power to the world of the imagination
Be-sphinxed

Monstrous masks and transgression are de rigueur in the liminal period. In OWS this is manifest in outrage transformed automatically into humor and play, and likewise by the NYPD in its growl, pepper spray, and medieval riot gear. The atomized mass of yesterday, without hope, has crystallized into a community defining itself through a new language and sense of collective. It is a movement that seems to have come out of nowhere, a messianic movement after the death of God that kindles our polymorphously perverse infancy with relish. More than anything else it is an attitude, a mood, an atmosphere, like John Cage's babbly lecture on weather mixing up Thoreau's *Civil Disobedience* with thunder and lightning, and this is why the politicians and the experts have a problem. They see OWS as primitive and diffuse because it has no precise demands—as if the demand for equality were not a demand, at once moral and economic, redefining personhood and reality itself. OWS

is akin to the "primitive rebels" that Eric Hobsbawm called the anarchists of Spain, a movement he saw as "pre-political." What the experts want is for OWS to submit to the language of the prevailing system. Yet is it not the case that merely to articulate such is to sell out the movement? There is as yet no language to express the "drift," as Lyotard called it, with '68 in mind. Politics as aesthetics is back. Politics as "affective intensity" is back too. "A successful attack on the belief in necessity would inevitably lead to the destruction of kapital's very main- spring," he wrote back then. The laws of equivalence are in suspense, and libidinal impulses are unhooked from prevailing norms. But the experts want to channel the messianic and transgressive impulse into their own need for pathological fame and power.

Saa finds a granite step that can serve as a backrest for sleeping while sitting. The plastic keeps off some of the rain, but everything is wet now. We doze, flitting between sleep and waking, bathed in that eerie green-yellow light that makes the sea of tarpaulins glisten, while beneath are bodies forming waves and

hillocks, like seals on the beach, vague outlines of animated be-ings pushing through. Is that our movement? Is that OWS, with its eerie green-yellow light and glistening tarp surfaces, with animal-like shapes pushing through? On the south side of the park where we lie, the rain beats down with demonic fury, and a crude sign in large white letters stands out above the police barriers: "Liberty and justice for all."

5:50 a.m.: sudden mic check. "Breaking news" (funny how they reproduce the media, especially at this crucial moment). The park has filled to overflowing in the past dark hour, along with rising tension, and three "echoes" or rebootings of the mic check are required to get to the people at the back.

Breaking news
Breaking news
Breaking news

The human microphone is bursting to capacity. Echoes chase echoes, and only the most alert ears and powerful voices are able to transmit anything. Hope and fear blur the message. The faces in the sea of faces around me in the magic hour of dawn are faces of angels and trust. We bond. We embrace with our eyes. You strain forward, then pivot 180 degrees to catch the repetition. We feel the incredible power of repetition—each repetition the same, each one slightly off. ("What did they say?") It could be natural forces: that sea, those waves again, that muffled thunder, on our side, now, natural force, natural history.

The deputy mayor has canceled the cleanup.

For a second a stunned silence
Then cheers of unbelievable elation
A young man asks for a mic check

Look up
Look up
Look up

See the sky
See the sky
See the sky

A new dawn
A new dawn
A new dawn

Mist clings to the skyscrapers. The mottled sky grows pink with promise of light. My sun, 'tis of thee. For a glorious moment, history and natural history fuse. Second nature dissolves. The time of the now.

Clickety clack
Clickety clack
Clickety clack

The end

NOTES

1. Thanks to Nancy Goldring for many of the photographs that appear here. Thanks to Danny Alonso, Salomeya Sobko, Alex Afifi, and Michelle Rosales for their written observations, to Yesenia Baragan for always keeping me in the know, to Ayesha Adamo for good cheer, and to David Goldstein for his record of signs sent to me by PLW.

POLITICAL DISOBEDIENCE

Bernard E. Harcourt

The man stood before the gates, waiting to gain entrance. Over the years, he had tried practically everything. He'd been polite to the gatekeeper, he'd cajoled him, he'd negotiated, he'd even tried to bribe him (and the gatekeeper took his money), but still, he was never let in. The gatekeeper played along, not wanting the man to think that there was anything he had failed to do to gain admission. Over the years, the man grew frail and weary and fell sick, and with his last breath he asked the gatekeeper why he had never let him in.

"Everyone comes to gain admission and get inside," the man said in Kafka's parable. "So how come, for all these years, I've been the only one waiting at this gate, begging for admittance?"

Seeing that the old man was about to die, the gatekeeper responded: "No one else could ever have been admitted here, because this gate was made only for you."[1]

#OCCUPYWALLSTREET
SEPTEMBER 17th.
BRING TENT.[2]

On September 17, 2011, protesters assembled in Zuccotti Park in lower Manhattan, spitting distance from Wall Street, and pitched their tents. Never once did they ask for permission. Never

once did they try to convince the gatekeeper, to cajole authority, to negotiate, to bribe, to seek permission. Never once did they try to gain entrance. In record time, similar protests spread across the United States to Chicago, Oakland, Washington, and Denver, and around the globe to London, Berlin, Frankfurt, Quebec, and Hong Kong. Within a few weeks, a movement was born.

In its steadfast refusal to compromise with political power, to conform to conventional politics, or to play by the rules, Occupy Wall Street immediately fashioned a new form of political engagement, a new kind of politics. It is a form of political engagement that challenges our traditional political vocabulary, that ambiguates the grammar we use, that playfully distorts our very language of politics. To turn a phrase, I would say that Occupy Wall Street instantiated a new form of "political disobedience"—a type of *political* as opposed to *civil* disobedience that fundamentally rejects the ideological landscape that has dominated our collective imagination, in the United States at least, since before the Cold War.

"Civil disobedience" accepts the legitimacy of the political structure and of our political institutions, but resists the moral authority of the resulting laws. It is "civil" in its disobedience—civil in the etymological sense of taking place within a shared political community, within the classical framework of *cīvīlitās*, within a common space of civil government.[3] Civil disobedience accepts the verdict and condemnation that the civilly disobedient bring upon themselves. It respects the legal norm at the very moment of resistance, and places itself under the sanction of that norm. If it resists the legal sanction that it brings upon itself, in truth it is no longer engaged in civil disobedience. As Dr. Martin Luther King wrote in his *Letter from Birmingham City Jail*, "An individual who breaks a law that conscience tells him is unjust and *willingly accepts the penalty* by staying in jail to arouse the conscience of the community over its injustice, is in reality expressing *the very highest respect for law*."[4] Civil disobedience aims not to displace the lawmaking institutions or the structure

of legal governance, but rather to change the existing laws by demonstrating their injustice.

"Political disobedience," by contrast, resists the very way in which we are governed. It resists the structure of partisan politics, the demand for policy reforms, the call for party identification. It rejects the very idea of expressing or honoring "the highest respect for law." It refuses to willingly accept the sanctions meted out by our legal and political system. It challenges the conventional way in which political governance takes place and laws are enforced. It turns its back on the political institutions and actors who govern us. And, beyond that, it resists the very ideologies that have dominated the postwar period.

Occupy Wall Street is political disobedience in precisely this sense: It disobeys not only our civil structure of laws and political institutions, but politics *writ large*. The Occupy movement rejects conventional political rationality, discourse, and strategies. It does not lobby Congress. It defies the party system. It refuses to align or identify itself along traditional political lines. It refuses even to formulate a reform agenda or to endorse the platform of any existing political group. Defying convention, it embraces the idea of being "leaderless." It aspires to rhizomic, nonhierarchical governing structures. And it turns its back on conventional political ideologies. Occupy Wall Street is politically disobedient to the core—it even resists attempts to be categorized politically. The Occupy movement, in sum, confounds our traditional understandings and predictable political categories.

Those who incessantly have wanted to gift the movement a reasonable set of demands—sympathizers like Paul Krugman or Nicholas Kristof—showed good will and generosity, but failed to understand that the Occupy movement was precisely about disobeying that kind of conventional political grammar. The strategy instead, as Occupy Wall Street immediately posted on its website, was to generate "a general assembly in every backyard" and "on every street corner."[5] To give birth to new spaces of occupation that open possibilities for new ideas, tactics, and

forms of resistance. To allow for occupations that generate pos-
sibilities without imposing ideologies.

In resolutely resisting the call for specific demands and con-
stantly reinventing itself, the movement liberated itself from
imposed stereotypes and projections, and from others' prejudg-
ments—from the tyranny of facile solutions and narrow-mind-
ed policy talk. It ambiguated itself, deliberately and incessantly,
in order to resist being pinned down, identified, or dismissed.
This was captured neatly in an article penned by three members
of the economics working group at Occupy London and pub-
lished in the *Financial Times* in January 2012—of all places. But
that's the point: to challenge assumptions and references.

> Fans of Friedrich von Hayek may be surprised to learn that the
> Austrian economist is the talk of Occupy London. Hayek's obser-
> vation that distributed intelligence in a voluntary co-operative
> is a hallmark of real economy rings true beneath the bells of St
> Paul's. Occupy is often criticised for not having a single message
> but that misses the point: we are committed to incorporating dif-
> ferent preferences before coming up with policies. In this sense,
> it could be said we work more like a market than the corporate
> boardroom or lobbyist-loaded politics—our ideas are radical but
> also just and democratically decided.[6]

This refusal to articulate policy demands or even a single,
unified message goes hand-in-hand with a rejection of the
worn-out ideologies of the Cold War—with a recognition that
those ideologies played right into the hands of the financial,
economic, and political elites, that they served to redistribute
massive wealth over the past forty years and concentrate it at
the very top of the socioeconomic pyramid. The coupling of
those ideologies enabled, rather than resisted, the dispropor-
tionate accumulation of capital.

In this sense, those who persistently have pushed conven-
tional political ideologies onto the Occupy movement—fellow

travelers like Slavoj Žižek or Raymond Lotta of the Revolutionary Communist Party—have missed the central point of the resistance. When Žižek complained in August 2011 in the *London Review of Books*, referring to the London riots, that we have entered a "post-ideological era" in which "opposition to the system can no longer articulate itself in the form of a realistic alternative, or even as a utopian project, but can only take the shape of a meaningless outburst,"[7] he failed to understand that many of the emerging protests around the world—and especially the Occupy movement—are precisely about *resisting those old ideologies*. It's not that the protesters can't articulate those ideologies or a utopian project or a coherent set of political maxims. It's that they are actively *resisting* them—they are being *politically disobedient*. And when Žižek declared a few months later at Zuccotti Park "that our basic message" is "What social organization can replace capitalism?"[8]—again, he missed a central axis of this new form of political resistance.

One way to understand the Occupy movement is to see it as a refusal to engage these sorts of worn-out ideological debates rooted in the Cold War. The point is that the conventional ideological coupling—the worn ideological divide with the Chicago Boys at one end and Maoists at the other—merely served as a weapon, in this country at least, for the financial and political elites: the ploy, in the United States, was to demonize the haunting specter of a "controlled economy" (that of the former Soviet Union or China, for example) in order to prop up the illusion of a "free market" and to legitimize the fantasy of less regulation—of what was euphemistically called "deregulation." By reinvigorating the myth of free markets, the financial and political architects of our economy over the past four-plus decades—both Republicans and Democrats—were able to disguise massive redistribution to the top by claiming that they were simply "deregulating," when all along they were actually *reregulating* to the benefit of their largest campaign donors.

This ideological fog blinded the American people to the per-

vasive regulatory mechanisms that inevitably and necessarily organize a colossal late-modern economy like ours, that necessarily distribute wealth throughout society, and that in this country quietly redistributed massive amounts of wealth to the top—to what the Occupy protesters metaphorically call "the 1 percent." It is precisely in this sense that many of the voices at Occupy Wall Street would accuse political ideology *on both sides*—on the side of "free markets," but also on the side of "big government"—for serving the few at the expense of the many; in effect, for paving the way to an entrenched regulatory system that privatizes gains and socializes losses.

The central point of the Occupy movement is that it takes *both* big government *and* the neoliberal illusion of free markets to achieve such massive redistribution. And if one looked closely at the tattered posters that lined Zuccotti Park, it was clear that the voices of protest challenged both sides of the ideological divide. Many voices were intensely antigovernment. Many stridently opposed big government—while others challenged the free market. This was captured neatly in one of my favorite posters from Zuccotti Park in October 2011: "I don't need sex. I get fucked by the government every day!" That's neither pro-government nor pro–big-government. It's certainly not Keynesian, nor socialist—quite to the contrary. And yet, at the same time, it is physically *occupying* Wall Street. It takes on both the "free market" and the corruptibility of "big government."

On this reading, the Occupy movement challenges both ends of the Cold War divide and the structure of the debate—the very opposition itself. It resists both ideological bedfellows, for good reason. The truth is that the free market is an illusion, as is the myth of a controlled economy. There never have been and never will be free markets—markets devoid of regulation. All markets are man-made, constructed, regulated, and administered by complex mechanisms that necessarily distribute wealth—that inevitably distribute wealth—in large and small ways. Tax incentives for domestic oil production and lower capital gains

rates are obvious illustrations; but there are all kinds of more minute rules and regulations surrounding our wheat pits, stock markets, and economic exchanges that have significant wealth effects: limits on retail buyers flipping shares after an IPO, rules allowing exchanges to cut communication to nonmember dealers, fixed prices in extended after-hours trading, even the very existence of options markets. The mere existence of a "free" exchange such as the privately chartered Chicago Board of Trade, which required the state of Illinois to criminalize and forcibly shut down competing bucket shops, has huge distributional wealth effects on farmers and consumers—and, of course, on bankers, brokers, and dealers.

The point is not simply that the space of economic organization is never "free" of regulation; most people would agree with that and with the need for a state apparatus to create and maintain markets—to stabilize them, make them more competitive, and keep them going in an orderly manner. The point, more radically, is that the very idea that there could be a scale or spectrum of more or less regulation, of more or less "free" markets, is itself fictitious. It is a myth that is false and dangerous and has blinded us to increasing forms of inequality over the past four decades. What the financial crisis of 2008 revealed—something that many of us knew beforehand—is that the federal government is prepared and willing, if necessary, to nationalize all of America's largest banks, insurance companies, and mortgage lenders in order to save the banking system. What this means, naturally, is that there is no significant difference between our existing free market system and a centralized government bank that fixes rates of interest on loans or controls the lending practices of its banks. Putting aside for a moment the fact that the Federal Reserve does just that and sets the cost of money, the most essential banking commodity, the financial crisis exposed the lie: there is no relevant difference between the government putting its full faith and credit—with all its immense resources—behind the American banking system and a government

fixing the prime rate in relation to a market. The market is not "freer" in the first case than in the latter.

In the end, it is pure fantasy to believe that there is any significant difference between the "amount of regulation" in the situation where the government is prepared to rescue the entire banking system—or the entire economy, for that matter; think here of the automobile industry—and the situation where the government actively manages the economy. The difference, in terms of the *amount* of regulatory intervention, is trivial at best. There are, of course, huge differences as to who reaps the benefits. What we have seen in this country is that the profits are privatized while the costs and losses are socialized. So there are, to be sure, enormous differences in the distribution of wealth, but not in the amount of regulation.

The semantic games—the talk of "deregulation" rather than *reregulation*—would have been entertaining had it not been for their devastating effects. As the sociologist Douglas Massey minutely documents in his book, *Categorically Unequal*, after decades of improvement, the income gap between the richest and poorest in this country has dramatically widened since the 1970s, resulting in what social scientists now refer to as the U-curve of increasing inequality.[9] Recent reports from the U.S. Census Bureau confirm this, with evidence in September 2011—when Occupy Wall Street hatched—that "the number of Americans living below the official poverty line, 46.2 million people, was the highest number in the 52 years the bureau has been publishing figures on it."[10] Today, 27 percent of African-Americans and 26 percent of Hispanics in this country—more than one in four—live in poverty.[11] Moreover, one in nine African-American men between the ages of twenty and thirty-four are incarcerated. The level of inequality has grown so much in this country that "the 400 wealthiest Americans have a greater combined net worth than the bottom 150 million Americans,"[12] and that "the top 1 percent of Americans possess more wealth than the entire bottom 90 percent."[13] Under President George W.

Bush's expansion years, 2002 to 2007, "65 percent of economic gains went to the richest 1 percent."[14]

It is these outcomes that pushed so many across the nation to this new form of "political disobedience." It is, I believe, a new type of resistance to politics along multiple dimensions—a resistance to making policy demands, to playing the political game, to partisan politics, to old-fashioned ideology. It bears a family resemblance to what Michel Foucault referred to as *critique*, resistance to being governed "in this manner," or what he dubbed "voluntary insubordination" or, better yet, as a word play on the famous expression of Etienne de la Boétie, "voluntary unservitude." What these times called for, Foucault suggested, was *"l'art de l'inservitude volontaire"*—in English, *voluntary unservitude* (using the negative force of the Old English prefix *un*) or *voluntary inservitude* (using the negative or privative force of the Latin prefix *in*).[15] By this, I take it, Foucault had in mind the idea of resistance to being governed—or, more precisely, to being governed *in this way*.[16]

A NEW GRAMMAR OF POLITICS

The new paradigm of political disobedience challenges our conventional political grammar and calls for a new way of speaking about politics. It demands a more careful syntax. To begin with, it makes no sense—and is in effect "unintelligible"—for anyone to claim to speak "for" or "on behalf of" the Occupy movement. As a leaderless movement—something I will come to shortly—no individual has the authorial voice to represent the movement or to make demands on its behalf. It is not even clear that Occupy Wall Street can legitimately delegate its voice to anyone through a general assembly—even though, at times, it has done so.[17] The resistance movement can only be "heard," syntactically, from its place of occupation, and only then, I take it, through the coordinated voice of assembled discussion and potential consensus—through the general assemblies.

To produce an effective normative statement *about* the Occupy movement—about what the movement should do—the speaker needs to be physically occupying. And not just physically present at an Occupy site, but "occupying" it, in the sense of having a self-imagination that they are part of the resistance movement. What it takes to "occupy," grammatically speaking, does not necessarily require a tent or sleeping bag, or even a poster (though that surely helps), but it does require a self-conception that one is protesting. Mere presence does not suffice. The journalist on the beat, the visiting tourist, the police officer patrolling the park, or the politician claiming to be responsive to the protesters' demands—none of these would be "occupying" unless they took the further step of conceiving of themselves as part of the resistance movement. (And even here, the self-conception cannot be policed in a conventional way; it is not as if anyone could go up to a person at an Occupy protest and tell them that they are not part of the occupation, if they genuinely believe that they are.)

What all this means, first, is that those who theorize the Occupy movement—as I am doing here—cannot speak with authorial voice "on behalf of" or "for" the movement, but can merely describe and theoretically examine the movement from outside. This makes it extremely difficult to understand exactly what *we* are saying or doing as theorists. A lot of our formulations no longer work or can be "heard" entirely well. This is especially true when we mix in advice. So, for instance, when the philosopher Peter Hallward contends in the editorial pages of the *Guardian* that "we will need to convert the polemical clarity of the new slogan—'we are the 99%'—into a commanding political standpoint,"[18] somehow the syntax doesn't work: it is not clear who "we" are in this statement, nor whom Peter Hallward is addressing. Are "we" the assembled protesters on the internet, the readers of the *Guardian*, the "leaders" of a movement, or critics? My sense is that this kind of statement, especially in the form of an editorial in the *Guardian*, is somehow inaudible and

slightly meaningless. It cannot be "heard" properly anymore.

This applies equally to the critics and commentators of the movement, whose syntax no longer seems to work fully. When, for instance, Nicholas Kristof argues in the *New York Times* that Occupy Wall Street should get an agenda,[19] or when the *Wall Street Journal* disdainfully remarks that the movement should stop engaging in "days of feckless rage,"[20] their statements do not fully make sense: it is as if their grammatical formulations cannot be "heard" properly given the leaderless paradigm of the new resistance movement. They sound like the inaudible noise in Gilles Deleuze and Félix Guattari's *A Thousand Plateaus*—or, perhaps more familiarly, the muted trombone sound that adults make in Charlie Brown cartoons.

The grammatical problems trace, first, to a spatial issue. Normative statements about Occupy Wall Street are functionally inaudible unless the speaker is physically "occupying." Peter Hallward cannot *audibly* tell anyone what Occupy Wall Street should do—any more than the *Wall Street Journal* could—unless Hallward is physically occupying an Occupy space. And you can't "occupy" while sitting at your computer, publishing an editorial, or writing an essay on Occupy. You cannot "occupy" at a distance from an Occupy site.

Second and connectedly, the problem is rhizomic. Because the movement is leaderless, there is no one to "speak to" apart from the assembled protesters at an Occupy site; and there is no way to "speak to" the resisters unless the speaker situates himself or herself as a member of the resistance movement. But there is also a third dimension to the problem—an authorial issue. The conventional sentence structure of the type "People should do *xyz*" rests on a claim of authority that no longer seems to hold. It is as if time-honored forms of knowledge and expertise no longer grammatically produce truthful statements. The contention of an economist, a politician, a columnist opining about what Occupy Wall Street "must do" to succeed is no longer fully meaningful because the authors of those sentences themselves

have failed, as evidenced by the 2008 financial debacle. Those who are trying to "steer" Occupy Wall Street in the "right direction"—whether in good or ill will—are likely responsible for where we are today. There is no authority to their statements. The syntactic difficulties extended, I think, within the movement and affected the women and men who were occupying. The proper nouns "Occupy Wall Street," "Occupy Chicago," and "Occupy London" as subject terms sound confusing coming out of their mouths, as compared to the pronoun "we." "We should do *xyz*" is far more "hearable." The reason is that it doesn't make sense for someone at Zuccotti Park, Grant Park, or Saint Paul's to talk about the Occupy movement as an object independent of himself or herself, independent of the very person occupying the site. Objectifying the movement is a bit like talking about oneself in the third person: it sounds presumptuous. It somehow excludes or resists self-identification.

These new grammatical forms open up the political space to multiple voices, views, and opinions—to a multiplicity of what the movement calls different "political persuasions."[21] For instance, someone occupying might say that they are pro-union, without the resistance movement *itself* being pro-union. Others may object and argue that unions are hierarchical institutions that reproduce new forms of oppression. In this sense, one could imagine hearing a large group of Occupy protesters arguing for the right of state employees in Wisconsin to collectively bargain, but it would not "make sense" for anyone to say that "Occupy Wall Street is pro-union." The grammatical structure of that sentence would not work.

The new syntactic order—or disorder—allows for a convergence of multiple views and an overlap of sometimes mutually exclusive ideas, without an exclusionary mechanism operating. There can be progovernment protesters next to antigovernment protesters, for instance, without the resistance movement needing to adjudicate between them. All those statements can be heard as long as the authors are physically present, occupy-

ing, self-identifying, and then voicing their opinions in terms of "we." Of course a leaderless movement could not enforce any of these new syntactic formations, but that's hardly an issue. Grammar works through who is "heard" and what "makes sense," far less by means of policing (except perhaps in grade school). It operates, for the most part, through auditory exclusion.

A "LEADERLESS" MOVEMENT

A central element and one of the most controversial aspects of the Occupy movement—the source of much criticism even among friends—is that it defines itself, in its own words, as a "leaderless" movement.[22] Some Occupy members quickly add that the movement is not so much "leaderless" as "leaderful"— that everyone in the Occupy movement is a leader. That is a charming touch, but the essential point of course is that there is a horizontal, nonhierarchical, and rhizomic quality to the leadership, rather than a vertical hierarchy, a party vanguard, or elected or self-proclaimed leaders.

The most frequent objection to a leaderless model is that it simply paralyzes political action. Žižek gave expression to this complaint with regard to the resistance movement in Greece, when he wrote:

> In Greece, the protest movement displays the limits of self-organisation: protesters sustain a space of egalitarian freedom with no central authority to regulate it, a public space where all are allotted the same amount of time to speak and so on. When the protesters started to debate what to do next, how to move beyond mere protest, the majority consensus was that what was needed was not a new party or a direct attempt to take state power, but a movement whose aim is to exert pressure on political parties. This is clearly not enough to impose a reorganisation of social life. To do that, one needs a strong body able to reach quick decisions and to implement them with all necessary harshness.[23]

Žižek's call for "a strong body" that acts with "all necessary harshness" is, of course, the complete antithesis of a leaderless resistance movement—far more reminiscent of a Leninist vanguard party. It is a stark contrast indeed.

It is worth emphasizing, though, that the notion of a leaderless movement—of being, as it were, "politically disobedient" to the core—may *open* possibilities rather than close them. It may serve to resist the crystallization of hierarchy and domination that so often recurs with the reestablishment of power, even when well-intentioned.

There is a striking passage from an interview with Foucault in the mid-1970s that is insightful here. When asked whether, after critique, there is "a stage at which we might propose something," Foucault responded: "My position is that it is not up to us to propose. As soon as one 'proposes'—one proposes a vocabulary, an ideology, which can only have effects of domination. . . . [T]hese effects of domination will return and we shall have other ideologies, functioning in the same way. It is simply in the struggle itself and through it that positive conditions emerge." It is only by open contestation and struggle that—"in the end," Foucault suggests—"possibilities open up."[24]

It certainly does seem that possibilities did open up. The Occupy movement gave life to a conversation in the United States—a conversation about inequality, about wealth, about excess—that had not been heard before. It was a conversation that was nonexistent—under identical economic conditions—in the months, years, even decades before the Zuccotti Park occupation. By eschewing old-fashioned partisan politics and ideological debates, new conversations blossomed with surprisingly tangible effects even on those in the political mainstream. This was a product, I believe, of the new paradigm of leaderless occupation. It was also the effect of a new syntax that was eloquently deployed by an impressive group of well-educated and articulate young women and men.

Some critics contend that the Occupy movement was in fact

led by organized groups, such as Adbusters, and that it had de facto leaders, such as those who could post or tweet for Occupy or who participated on more important committees. I've heard Occupy members respond to these objections by saying that the committee structure has always been open and that the responsibilities and positions rotate constantly. My sense, though, is that this debate is beside the point. The issue is not whether the Occupy movement has ever achieved perfection—a form of complete "leaderlessness"—but, rather, that it embraced an *aspiration* toward the goal of resisting leaders. The effort to be leaderless is a constant struggle, and a difficult one at that. There will always be a tendency toward leadership in a political movement. The important point here is not that the Occupy movement achieve leaderlessness, but that it strive for it.

Interestingly, there were features of Occupy Wall Street—some internal structural elements—that seemed to promote that goal. The apparatus of general assemblies, "human microphones," and hand signals contributed to the effort. The "human mic," as a form of expression, communication, and amplification, has the effect of undermining leadership. It interrupts charisma. It's like live translation: the speaker can only utter five to eight words before having to shut up while the assembled masses repeat them. The effect is to defuse oratory momentum, or to render it numbingly repetitive. The human mic also forces the assembled masses to utter words and arguments they may not agree with—which also has the effect of slowing down political momentum and undermining the consolidation of leadership.[25] Somewhat prophetically, these creative measures reinforced the leaderless aspect of the movement itself.

REFUSING TO PLAY THE GAME

Another contentious aspect of the movement has been its resistance to formulate demands or to coalesce behind a single, unified message. "Where the movement falters," Nicholas Kristof

wrote in the *New York Times*, "is in its demands: It doesn't really have any."[26] Or as another journalist wrote, "Unless and until this anger is channeled into something that catalyzes a policy debate, it is not particularly newsworthy."[27]

Here too, the Occupy movement has been disobedient. It has deliberately resisted what I would call the privileging of choice. Choice—especially rational and calculated choice—is a hallmark of these late modern times. In the West there is a premium on deliberate decision making, on reason, on intentionality, on sovereignty. To make a free, knowing, deliberate, and intelligent choice is the very epitome and the project of modernity, the project of Enlightenment. It is what emancipates us from our "self-incurred immaturity," as Kant so famously suggested—from the "inability to use one's own understanding without the guidance of another."[28] As Renata Salecl poignantly observes in her book, *Choice*, the privilege of choice runs deep:

> From the late seventeenth century on, the Enlightenment project promoted the idea of choice—giving rise to our modern conceptions of political freedom, the relationship between mind and body, lover and loved, child and parent. And capitalism, of course, has encouraged not only the idea of consumer choice but also the ideology of the self-made man, which allowed the individual to start seeing his own life as a series of options and possible transformations.[29]

The sovereign choosing self is at the heart of the liberal conception of Western society. No wonder there would be so much pressure on the Occupy movement to make demands, to stake out policy reforms. But the Occupy movement resists. Why? It's grammatically impossible to speak for the movement—as I have already discussed—but I suspect that the resistance is, in part paradoxically, strategic. The resistance to formulating demands allows for wider participation—for a movement with people of, in its own words, many "political persuasions."[30] Resisting

choice unifies rather than fractures. It also avoids producing a set of demands that could easily be met, yet amount to nothing. As we know too well, good policy reforms can easily be diluted through amendment, revision, and technicalities that ultimately produce more loopholes than solutions.

The Volcker Rule is a perfect illustration—and, not surprisingly, it is one of those "specific suggestions" that Kristof proposed to Occupy Wall Street.[31] The Volcker Rule began with a three-page letter to the president by Paul Volcker, former chairman of the Federal Reserve, proposing a simple rule that would ban proprietary trading by commercial banks. Soon enough, in the hands of Congress it expanded to ten pages of legislation with the passage of the Dodd-Frank Act. Those ten pages then mushroomed thirtyfold, and got truffled with loopholes.[32] When the proposed regulations finally reached the public, the *New York Times* reported, "the text had swelled to 298 pages and was accompanied by more than 1,300 questions about 400 topics."[33] Even Paul Volcker was no longer really in favor. "I don't like it, but there it is," Volcker said. "I'd write a much simpler bill. I'd love to see a four-page bill that bans proprietary trading and makes the board and chief executive responsible for compliance."[34]

Kristof offered the Volcker Rule as the perfect solution for "those who want to channel their amorphous frustration into practical demands."[35] But it is precisely the trajectory of a simple policy proposal like the Volcker Rule that should give us pause. In the end, the Occupy movement's resistance to simple policy demands may be one of its greatest strengths. The resistance to proposing policies avoids reconstructing oppressive relations of power. "Resist to exist," read a poster at Zuccotti Park. The moment of resistance is key to the Occupy movement. It's the moment when the movement says: We will not be governed like this anymore. We will not wait any longer at this door. We will not play your games. We will not seek permission to enter. We will no longer simply obey.

A FUTURE FOR THE LEFT

In an important essay entitled "The Grand Dichotomy of the Twentieth Century," Steven Lukes explored the significance of the left in this country and in Europe—proposing a tentative definition and, drawing on Eric Hobsbawm's cartographic work, suggesting a three-part periodization. In Lukes' account the left represents, fundamentally, "a critical, strongly egalitarian project" that "allows for successive and varying interpretations and reinterpretations of what unjustified inequalities consist in and of how—through what methods and programmes—they can be reduced or eliminated."[36] Throughout the past several centuries, Lukes suggests, the left has been characterized by a commitment to "the *principle of rectification* and the right by opposition to it," and in this sense it belongs to "a strongly egalitarian family, committed to rectification, whether radical or reformist," with a long "family history."[37]

Eric Hobsbawm earlier had sketched a three-part periodization of the left that Lukes substantially embraces, starting with a first left that was "moderate though willing to mobilise the masses in pursuit of its political ends: it fought 'to overcome monarchical, absolutist and aristocratic governments in favour of the bourgeois institutions of liberal and constitutional government.'"[38] The second left, in Hobsbawm's account, "turned to the class struggle and formed around workers' movements and socialist parties in the nineteenth century" and fought increasingly "for public ownership and the planning of the economy, the rights of all to work and for social rights."[39] This second left lasted until the oil crisis of 1973, and had its "golden age" between 1945 and 1970.[40] The third left was far less unified, and ranged across a broader set of issues, incorporating many single-issue causes. To Lukes and Hobsbawm, both writing in the early 2000s, this third left resembled "a series of single-issue movements, such as the women's, anti-racist and environmental movements, social movements belonging to what came to

be called 'identity politics,' and various internationally focused movements from anti-nuclear campaigns and the anti–Vietnam War movement to a burgeoning variety of movements."[41]

Lukes concluded his essay, first published in 2003, unsure of what would emerge of this third left. He intimated that the internationally-oriented movements made up "the most dynamic segment of the third left" and represent its main "achievements."[42] But in response to the central question, the future of this third left, Lukes hesitated: "By the end of the century none of these questions was decisively answered or even answerable."[43]

In somewhat parallel fashion, Eli Zaretsky traces in his book *Why America Needs a Left* an American story about a succession of three radical social movements—from slavery abolitionists to populist, labor, and socialist movements leading to the New Deal, to the civil rights and New Left protests of the 1960s. Zaretsky paints a history of recurring deep structural crises—nineteenth-century slavery, turn-of-the-century laissez faire capitalism, postwar globalization and the Cold War—each of which would regenerate a Left that would formulate renewed demands for equality along racial, socioeconomic, and civic-political lines. Race and resistance to American free-market capitalism are the dominant drivers, making Zaretsky's account a uniquely American history of the left, markedly different in these ways from the account on the European continent. Writing a decade after Lukes or Hobsbawm, Zaretsky identifies a fourth structural crisis today, corresponding to what many call the current "neoliberal" predicament. He too ends his book with a timely question: "Is it possible to build a fourth American left?"[44]

The question for us, to rephrase it somewhat, is whether the Occupy movement forms part of an emerging fourth American left. And my sense, looking back on the events since September 2011, the experiences of the Occupy protests, and especially the writings of the Occupy movement, is that the answer is yes. The

words, posters, and writings that have emerged from Zuccotti Park and around the world point strongly in the affirmative. And recent studies of social movements confirm this as well.

Catherine Corrigall-Brown's new study, *Patterns of Protest*, is particularly enlightening in revealing the magnitude of political activism in America today: it turns out, surprisingly, that almost a full two-thirds of Americans have participated "in a social movement organization or attended a protest at some point in their lives."[45] Some scholars have even begun to call the United States a "social movement society."[46] And this growing political activism is likely to compound: studies of 1960s protesters find that political mobilization has long-lasting effects. The 1960s activists "continue to espouse leftist attitudes, define themselves as liberal or radical in orientation, and remain active in contemporary movements and other forms of political activity."[47]

Robert Putnam's notorious diagnosis of the demise of civic participation is only half the story, apparently. Americans may be bowling alone, but they are marching together. Political activism is greater today than it was in the 1960s and 1970s. Although the protests back then may have garnered more attention, as Corrigall-Brown shows, "protest levels in the United States and other modern industrial democracies are considerably higher today."[48]

Recent writings from the Occupy movement provide strong evidence of a renewed and emerging left. As a form of raw protest and resistance, of pure critique, of "political disobedience," the Occupy movement has tapped a deep well of solidarity, passion, and community, and has provoked a wide-scale political reawakening. Drawing on successful recent mobilizing strategies, the Occupiers have cobbled together—in a form of bricolage that resembles their tarped tents and cardboard posters—a unique mix of rhizomic leaderlessness, consensus-based general assemblies, and spatial occupations, and have embraced nonviolence and polyvalence. So far, they have also avoided the

kind of divisive internecine battles that so often have immolated the left. It is indeed likely that this movement represents, in Noam Chomsky's words, "a significant moment in American history."[49]

By consciously avoiding the closures that inevitably accompany the act of proposing specific policy reforms or embracing particularistic ideologies, the Occupy movement has opened possibilities that many no longer believed existed. That is, at least, the palpable feeling one gets reading the texts that the movement generated. It is what you hear, for instance, in the voice of Manissa Maharawal in *Occupy!*—a collection of essays by Occupiers—as she rides her bike home after an intense debate at Occupy Wall Street over issues of racism, classism, and patriarchy:

> Later that night I biked home over the Brooklyn Bridge and I somehow felt like, just maybe, at least in that moment, the world belonged to me as well as to everyone dear to me and everyone who needed and wanted more from the world. I somehow felt like maybe the world could be all of ours.[50]

This palpable feeling pervades the personal accounts. You hear it so vividly in Michael Taussig's essay in this volume, "I'm So Angry I Made a Sign." A deep current of emancipation, of liberation, of renewed hope, and of political and spiritual reawakening runs through the stories. It is as if political disobedience engenders possibilities. In their preface to *Occupy!*, the editors note:

> The genesis of this book is that we were lucky enough to be in New York, and in America, at the start of the occupations of public ground that began in September 2011. We started as participant-observers As time went on, we became observers more explicitly. Something was unfolding, which was becoming one of the most significant and hopeful events of our lifetime.[51]

This idea—"one of the most significant and hopeful events of our lifetime"—runs throughout the personal accounts like a leitmotif. There is a palpable element of exuberance in the collective assemblies, in the communal sharing, in the lived experiences of the occupiers. "What unified this disparate throng was a tangible sense of solidarity, a commitment to the cause of the occupation, but also an evident commitment to each other," the Writers for the 99% recount in their "Inside Story" of Occupy Wall Street. "It was not unusual for food packets of biscuits or pretzels, or bottles of water to be passed hand-to-hand around the rows, shared by strangers who had just become comrades."[52] There was an overwhelming sense of community.

The Occupiers found pleasure in protest too. The dancing ballerina, the drumming circles, the mimes, the human microphone, the imaginative, hilarious, haunting posters . . . *the posters, God, they were so good!* The mix of humor, anger, art, and politics was so evidently inspiring to the Occupiers. "They piss on us and call it trickle-down."[53] "Money talks . . . too much. Occupy!" reads another poster, with a belt on the bull's muzzle.[54] "I'm not a hippy. I have 3 jobs. But I'm still broke."[55] "When injustice becomes law, resistance becomes duty."[56] The mix of playfulness and sincerity, of anger at injustice, was overwhelming—and deeply refreshing.

There was indeed a strong sense of community, but also of each person's place in the collective—whether they were homeless, struggling, working, or privileged. There was a keen awareness of race, class, and gender. The Writers for the 99% describe a tactic they call "step-up/step-back":[57] the concept is for "those requesting time to speak to consider whether they might 'step up' by recognizing their relatively privileged role in society at large and cede the floor, or 'step back,' to allow someone from a group with traditionally less opportunities to have their voice heard."[58] There were lengthy engagements with the socioeconomic dimensions of occupation—especially within Zuccotti Park, where there was even talk of an "Upper East Side"—and

efforts to address these tensions. And throughout, a desire to not allow the politics of class to eclipse issues of identity, or vice versa, but to work toward an integrated notion of class and identity politics, in the manner of Lisa Duggan's *Twilight of Equality*. The reason why America needs a left, in Zaretsky's view, ultimately turns on the relationship between radical left movements and the more liberal democratic mainstream. In Zaretsky's account, both need each other: "Without a left, liberalism has become spineless and vapid; without liberalism, the left becomes sectarian, authoritarian, and marginal."[59] The first is surely true—and, sadly, in evidence today. But the second part of Zaretsky's claim is less accurate. Truth is, there's hardly ever been a time in American history without a liberal mainstream. All the major political crises have triggered both a liberal response and a more radical left, and in practically all the cases (except for brief periods) the radical elements have lost out— which is also true in Europe, as evidenced by the eclipse of the Levellers in England in the aftermath of that country's civil war and of course, eventually, of the Jacobins in France.

No, the "sectarian, authoritarian, and marginal" tendencies of prior left movements cannot be attributed to the absence of a liberal mainstream. They are, rather, a distinctive propensity of the left—or at least, of the various lefts in the past. One of the most striking features of the Occupy movement is precisely the lengths to which it has gone to avoid these pitfalls. The Occupy movement deliberately resists sectarian and authoritarian tendencies—which, not surprisingly, has prompted criticism from both the more militant on the left and traditional mainstream liberals. By specifically resisting the urge to formulate policy demands, endorse party politics, or embrace the worn-out ideologies of the Cold War, by strenuously pushing back against efforts to empower particular individuals or vanguard groups, by insisting on the primacy of pure resistance, outrage, and political protest, by allowing all voices to be heard, at the risk of cacophony—the Occupy movement has very deliberately cul-

tivated a nonsectarian, nonauthoritarian ethos. As the Writers for the 99% have emphasized, "Zuccotti Park is home to both proponents of specific reforms such as reinstating the Glass-Steagall Act, as well as revolutionaries calling for the complete overthrow of capitalism, or indeed an anarchistic abolition of all hierarchies in American government and society."[60]

The most striking feature of the Occupy movement remains this palpable sense that something meaningful has happened. "'We found each other,'" Naomi Klein writes. "That sentiment captures the beauty of what is being created here. A wide-open space (as well as an idea so big it can't be contained by any space) for all the people who want a better world to find each other. We are so grateful."[61] Chomsky adds, "I've never seen anything quite like the Occupy movement in scale and character."[62] Its impact has already been felt not only on political discourse in the United States today, but also on politics on the ground.

"WE THE PEOPLE": MYTH AND DEMOCRATIC CHALLENGE

Judith Butler said, at Occupy Wall Street, "We're standing here together making democracy, enacting the phrase 'We the people!'"[63] A bold statement—indeed, a real reappropriation that raises deep questions about this collective myth.

In an odd way, it almost feels as if the Occupy movement had it harder than other contemporary resistance movements—dare I say, harder than even the Arab Spring revolutions. To be sure, the resisters in the Arab world faced (and may still face today) brutal authoritarian regimes. They risked, and in many cases lost, their lives. Their unmatched courage has been an inspiration around the world. On that count, they have stared down a far more violent and oppressive adversary than anyone else. *But they had one.* They had an identifiable adversary—oppressive and authoritarian regimes—that they could target and topple. They had and have a concrete goal, grievances, an objective, demands, and a vision for reform—all wrapped into one.

They could resist until the authoritarian regime ceded power. It is difficult to say, but the protesters in the Arab world had a cruel advantage: an external oppressor.

By contrast, what the experience of the Occupy movement has revealed is that there is no similar adversary to "overthrow" in the United States. In Egypt there was President Hosni Mubarak's regime, and then the military establishment. In Tunisia the people could oust the longtime president, Zine el Abidine Ben Ali. In Libya there was Colonel Muammar Gaddafi. In Syria, President Bashar al-Assad. Even in Europe today, the political resistance movements have specific targets. In Greece there are the Germans and French, their austerity measures, and the International Monetary Fund. But in the United States there is nothing to topple and no one to oust. With political elections every two to four years, the American populace can vote their politicians out of office, but hardly anything changes. There are moments of victory and defeat—of celebration and mourning. For some, the celebration was Grant Park on election night in November 2008; for others it was two years later, in 2010. These were moments of utter triumph and loss, ecstasy and despair. And yet so little changed. Imprisoned populations continue to grow. Inequality continues to increase. The Democratic and Republican years fade into each other and into the steady, plodding march toward mass incarceration and growing inequality. Only state bankruptcy and a brutal recession seem to slow down prison growth today—and perhaps only temporarily.

The genius of democratic structures of governance is that they provide no target anymore. There is no monarch, no tyrant, no dictator. By cutting off the king's head—not just metaphorically or methodologically, as some have urged us to do, but physically—"we the people" have so diluted accountability and attribution that we are left unable to find a target to engage politically. We have become the tyrants. It is devilishly ingenious.

To put it another way: The four hundred wealthiest Americans have a combined net worth greater than 150 million Amer-

icans. Once upon a time, they would have been marked as a class apart, nobility, perhaps an aristocracy. They would have had titles; their social and political relations would have been set apart by feudal or aristocratic legal regimes. Their "excess of power" would have been legally recognized. Just as we had special codes for black slaves in the antebellum period, or Black Codes for African-Americans during Reconstruction and Jim Crow, there would have been distinct legal regimes in this country. At least, at some earlier time. But not today. We are all equal before the law. We are all—well, practically all—citizens, with equal voting rights and equal civil rights. Again, not all—not certain felons who have been disenfranchised, or those too poor or uneducated to be able to comply with our administrative hurdles. But extending the franchise here and, equally importantly, fighting against insidious forms of voter suppression—noble endeavors indeed—are practically irrelevant when a handful of Americans control such massive resources. The partisan system, dual party politics, Congressional debates, presidential elections—there is neither anything to overthrow nor any simple way out. That, I take it, is part of what was being said at Occupy Wall Street.

DISCIPLINE AND OCCUPATION

Angela Davis has suggested that the true goal of the Occupy movement was to "(Un)Occupy": to *stop* occupations around the globe, especially in the Middle East.[64] W. J. T. Mitchell, in his marvelous essay "The Arts of Occupation," explores the paradoxical naming, the trope of *occupatio*: "The demand of *occupatio* is made in the full knowledge that public space is, in fact, 'pre-occupied' by the state and the police, that its 'pacified' and democratic character, apparently open to all, is sustained by the ever-present possibility of violence."[65]

The Occupy movement, there is no doubt, has played with the different connotations of "occupation." There is a certain doubleness here—especially apparent in the movement's re-

lationship to discipline. The general assemblies have imposed
an orderliness, a regular process, and rules. There are facilita-
tors with designated jobs, and stack-takers. There are common
hand signals with shared meanings. A triangular signal raises
an issue of process. Rolling arms mean the people have heard
enough. Interventions need to be short. There is the possibility
of a block. The human mic controls. "Mic check, mic check"—
the mic check becomes a command, an order, a call to atten-
tion. And the rules are enforced by the subtle pressure of the
assembled group.

I have witnessed discipline at work both at Zuccotti Park and
at Occupy Chicago. Quite impressive: subtle, forceful, based on
an overwhelming sentiment of shared purpose. At a general as-
sembly in Zuccotti Park on the evening of October 24, 2011, the
drummers reluctantly but willingly agree to limit their drum-
ming hours, and the extreme voices at the edges of consensus
are silenced. The shipping committee cajoles the gathered pro-
testers into agreeing to a monthly contract with the local UPS
Store at $500 per month, despite reservations that it's a "corpo-
rate account." At a teach-in at the School of the Art Institute of
Chicago on December 2, 2011, a protester begins challenging
one of the speakers, asking questions out of turn about Stalin's
purges, repeatedly interrupting the conversation, breaking the
order of "stack." The other protesters ask him to respect the
process and put himself "on stack." He continues to heckle the
speaker. The others start to shout him down, and eventually ask
him to leave. There is unison in the room, a shared sense that
the rules need to be respected. There is enforcement brought to
bear on the disorderly protester. He is excluded from the gath-
ering. The conversation resumes.

Christopher Berk, a doctoral student at the University of
Chicago, spent several nights in Zuccotti Park at Occupy Wall
Street as a participant observer. One night, Berk joined the se-
curity committee for its evening patrol and patrolled a section
of the park from midnight to 3:30 a.m. on the morning of Octo-

ber 25. Within Zuccotti Park, which is only 3,100 square meters in area, there were four "hotspots" outlined that morning. In Berk's area alone—one of the four hotspots—there were five to six incidents that required intervention, including one fight, two or three verbal altercations, one theft, and one mental illness-related incident. These involved the expulsion of at least one protester. Here is an extract from Berk's field notes:

> 12:05 am. 5 minutes after shift begins! Increasingly loud yelling, threats, arguing from west side of camp (Liberty and Trinity, near card playing table). Someone yells "security!" Start running over. First one there. 2 people, 1 is extremely drunk. One (will call him "A"): visibly drunk, stumbling, stained white t-shirt, age late 20s. Other ("Cowboy"): skinny, mid-30s, wearing a cowboy hat. Within 10 seconds about 6–8 other members of security group converge. Men separated and encircled by security group. I'm in the group talking with "Cowboy." He's very anxious and angry. Pointing a finger, periodically continues to shout at "A." Head of the watch shift starts asking questions about the incident. "Cowboy" explains that "A" attacked a girl in the camp. Other witnesses clarify and verify: "A" was seen grabbing a girl's arm and shouting epithets. Community watch group asks "A" to leave the camp. Explained behavior is absolutely not tolerated. Escorted out. Hour later, "A" comes back. Tells security he doesn't have anywhere else to sleep—he's escorted back in, told he can sleep it off, then must leave in the morning. "A" passes out on mat. I'm asked to keep an eye on him for the rest of the shift. Doesn't stir.

Another entry in Berk's field notes recounts a verbal altercation:

> Two men shouting. Shoving. Run over. Just Mark and I. Conflict over camping space (far edge, Trinity side, drum circle). I notice one man ("A") is a member of the security team from a different shift. Big, tall (about 220lbs)—anxious, agitated. Notice the

other man's ("B") gear is scattered along the steps. "A" explains that the space where "B" camped should be a safe-space area for folks (women in particular) who wanted extra protection at night (not the official safe-space at other end of the park). "B" says he was never informed of this. I take "A" aside and talk to him. I tell him his intention to create a safe-space is admirable, but that the NYPD is just itching for an excuse to come in and break up the camp over incidents like these—it's important to think about the whole group of campers. After talking with him for a few minutes, he ("A") calms down and agrees to move to a different section of the park.

An occupation requires discipline, and not just the kind of discipline that accompanies a protest or a march. It calls for committee structure—open to all, to be sure, but structured—general assemblies, websites, Twitter accounts, UPS deliveries, teach-ins, libraries, medical assistance, and volunteer lawyers. In Chicago it even called for a "soup brigade" (courtesy of dedicated elderly women from Hyde Park).[66] Occupations, I take it, are demanding—especially this one, which was an experiment in real time, constantly exploring new forms of social organization and experimenting with new ways of governing itself.

OUTLAWING DISSENT

The backlash to Occupy was immediate and forceful—first, with draconian measures to silence the protesters through arrest and new antiprotest laws. Not surprisingly, Chicago—with its long history of repressive measures against protest, from the 1886 Haymarket Riots to the 1968 Democratic National Convention and 2003 antiwar protests—took the lead.

The irony did not escape everyone. In Grant Park three years earlier, on election night 2008, huge tents were pitched, commercial sound systems pounded rhythms and political discourse, and enormous television screens streamed political

imagery. More than 150,000 people blocked the streets and "occupied" Grant Park—congregating, celebrating, debating, and discussing politics. That evening President-elect Barack Obama addressed massive crowds late into the night, and the assembled masses swarmed the park into the early morning hours. It was a memorable moment, perhaps a high point of political expression in Chicago.

The low point came three years later. On the evening of October 15, 2011, thousands of Occupy protesters marched to Grant Park and assembled at its entrance to engage once again in political expression. But this time the assembled group found itself surrounded by Chicago police officers and wagons. The police presence grew continually as the clock approached midnight. Within hours, the police began to arrest protesters for staying in Grant Park beyond the 11 p.m. curfew in violation of a mere park ordinance. They could have issued written citations and moved the protesters to the sidewalk. In fact, that's precisely what they would do a few weeks later at a more obstreperous protest by senior citizens at Occupy Chicago.[67] But on October 15 and the following Saturday night, the police physically arrested and handcuffed more than three hundred protesters, treating the municipal park infractions as quasicriminal charges. They transported the protesters to various police stations across the city, booked and fingerprinted them, and detained them overnight in holding cells, some for as long as seventeen hours. The city then continued to aggressively prosecute the cases throughout 2012—chilling political speech and raising genuine First Amendment concerns.[68]

To make matters worse, Chicago's new mayor, Rahm Emanuel, would follow up the three hundred arrests by enacting draconian antiprotest laws. Under the guise of the then-upcoming NATO and G8 summit meetings, to be held in Chicago in May 2012, Emanuel would tighten his authoritarian grip on speech. Almost as if he were following the script from Naomi Klein's *Shock Doctrine*—as if he were reading her account of Milton

Friedman's "Chicago Boys" as a cookbook recipe rather than as the ominous episode it was—Emanuel successfully exploited, in record time, the fear of summit violence to increase his police powers and extend police surveillance, to outsource city services and privatize financial gains, and to make permanent new limitations on political dissent. It all happened—very rapidly and without time for dissent—with the passage of rushed security and antiprotest measures adopted by the Chicago City Council on January 18, 2012.

"Rule one: Never allow a crisis to go to waste," Rahm Emanuel is reported to have said to the *New York Times* back in 2008. "They are opportunities to do big things."[69] More ominous words could not have been spoken. In this case, it seems, the "big thing" was the suppression of political expression. And it followed a well-known script, right out of the *Shock Doctrine*—a script, sadly, that we are all too familiar with now: first, hype up a crisis and blow it out of proportion (and if there isn't a real crisis, create one), then call in the heavy artillery and rapidly seize the opportunity to expand executive power, redistribute wealth for private gain, and suppress political dissent. As Milton Friedman wrote in *Capitalism and Freedom* in 1982, "Only a crisis—actual or perceived—produces real change. When the crisis occurs, the actions that are taken depend on the ideas that are lying around. That, I believe, is our basic function . . . until the politically impossible becomes politically inevitable."[70] Today, it's more than mere ideas that are lying around; for several years now, and especially since 9/11, the blueprints and examples are scattered all around.

Step 1: Hype a crisis, or create one if a real one isn't available. Easily done. With images from London, Toronto, Genoa, and Seattle of the most violent anti-G8 protesters streaming on Fox News along with repeated references to anarchists and rioters, the pump was primed. Rather than discuss the peaceful Occupy Chicago protests of the preceding three months, city officials and the media focused on what Fraternal Order of Police

President Michael Shields called "people who travel around the world as professional anarchists and rioters" and a "bunch of wild, anti-globalist anarchists."[71] The "looming crisis" headlined Emanuel's draft legislation, now passed: "WHEREAS, Both the North Atlantic Treaty Organization ("NATO") and the Group of Eight ("G8") summits will be held in the Spring of 2012 in the City of Chicago" and "WHEREAS, The NATO and G8 Summits continue to evolve in terms of the size and scope, thereby creating unanticipated or extraordinary support and security needs"[72] Clearly, the "crisis" called for immediate action.

Step 2: Rapidly deploy excessive force. Again, easily done. In this case, Emanuel gave himself the power to marshal and deputize—I kid you not—the United States Drug Enforcement Administration (DEA), the Federal Bureau of Investigation (FBI), the United States Department of Justice's Bureau of Alcohol, Tobacco, and Firearms (ATF), and the entire United States Department of Justice (DOJ)—as well as state police (the Illinois Department of State Police and the Illinois attorney general), county law enforcement (the state's attorney of Cook County), and any "other law enforcement agencies determined by the superintendent of police to be necessary for the fulfillment of law enforcement functions."[73] As one commentator suggested, the final catch-all allowed Emanuel to hire "anyone he wants, be they rent-a-cops, Blackwater goons on domestic duty, or whatever."[74] Thanks to the coming G8 meeting, the Chicago Police Department had gotten a lot bigger. Fox News warned: "There will be hundreds, perhaps thousands of federal agents here."[75]

Emanuel also gave himself the power to install additional surveillance, including video, audio, and telecommunications equipment—not just for the period of the NATO summit. The new provisions of the substitute ordinance applied "permanently": there was no sunset provision on either the police expansion or the surveillance.[76] Thanks to the mobilization of the Occupy movement (including their mock funeral for the

Bill of Rights) and other groups like the American Civil Liberties Union, some of Emanuel's other draconian provisions were scaled back. Emanuel dropped his proposals to increase sevenfold the minimum fine for resisting arrest (including passive resistance) from $25 to $200, and to double the maximum fines for resisting arrest or violating the parade ordinance. But the rest of his proposals passed the City Council.

Step 3: Privatize the profits and socialize the costs. In Chicago that would translate into Emanuel outsourcing city services to private enterprises while making sure the public would indemnify those private companies from future lawsuits. This was a two-part dance—again, one with which we have become too familiar. First, city services are outsourced, often to circumvent labor and other regulations, and the income side of public expenditures is shifted over to private enterprise and its employees.[77] Second, the agreements can be entered into "on such terms and conditions as the mayor or such designees deem appropriate"—terms which include, importantly, "indemnification by the city." In other words, any lawsuits fall on the city's taxpayers. The public will be left holding the bag if and when there is any abuse or other mismanagement by private employers.

Step 4: Use the crisis to expand executive power permanently and repress political dissent. Most of the ordinance revisions, it turns out, did not sunset with the departure of the NATO delegates. To be sure, there was a sunset provision for those contracts that specifically involved "hosting the NATO and G8 summits"—those provisions expired on July 31, 2012, two months after the summit—but not for the expanded police powers, the increased video surveillance, or the other changes to the protest permit requirements. Those will be with us for the foreseeable future.

The new rules affecting permits for protests and marches now include details that impose onerous demands on dissent. On the parade permit applications, for instance, protest organizers must now provide a general description of any sound am-

plification equipment that is on wheels or is too large for one person to carry, and of any signs or banners that are too large for one person to carry. These may sound like small details, but they are precisely the kind of minutiae that are impossible to satisfy, and which, as a result, empower and expand police discretion to arrest and fine. In essence, they make it harder to express political opinions.

This is, in the end, another glaring example of what many call the paradox of neoliberal penality: the purported liberalization of the economy (here, the privatization of city services) goes hand in hand with massive policing. Notice the paradox: the city's claims to be incompetent or unable to perform its ordinary functions imply that we need to outsource city services but at the same time augment city police powers. This change was accomplished so quickly and seamlessly—passed practically overnight—that few seemed to notice or had time to think through the long-term implications. There was no mention in the *New York Times*, and only a small story in the *Chicago Tribune*. The crisis and the fear of outside agitators, professional anarchists, and rioters—splashed on TV screens direct from London, Toronto, Genoa, Rome, and Seattle—was enough to create a permanent state of exception in which ordinary political speech becomes severely restricted.

POLICE STATE 2012

Quashing the right to free speech was just the beginning. Then came forcible police evictions of Occupy protesters in New York, Oakland, the District of Columbia, Montreal, Toronto, Berlin, and elsewhere; the pepper spraying of peaceable protesting students at the University of California, Davis; the brutal arrests by the New York Police Department of peaceful protesters for no good reason;[78] the phalanx of police officers in black riot gear surrounding peaceful protest.

The police response to the Occupy movement was brutal.

Occupy was forcibly shut down in most cities, and it became an excuse for the expansion and full-emergence of a "new normal": an urban militarized American police state. Chicago, again, took the lead. With the G8 and NATO summit meetings looming, the city of Chicago went into security lockdown.[79] Starting twenty-four hours before the NATO meeting, the Chicago police began shutting down—prohibiting cars, bikes, and pedestrians on—miles of highways and streets in the heart of downtown Chicago, creating a security perimeter around the downtown area and McCormick Place (where the NATO summit would be held). Eight-foot-tall, antiscale security fencing came up all over that perimeter and downtown, including Grant Park;[80] the Chicago police—as well as myriad other federal, state, and local law enforcement agencies, such as the FBI and the US Secret Service—were out in force on riot-geared horses,[81] bikes,[82] and foot patrol—batons at the ready. The Philadelphia Police Department sent reinforcements, as did police departments in Milwaukee and Charlotte-Mecklenburg, North Carolina.[83] Meanwhile, F-16 warplanes "screamed through the skies as part of a pre-summit defense exercise" and helicopters hovered incessantly.[84]

The Chicago Police Department spent a million dollars in "riot-control equipment" in anticipation of the summit. According to the *Guardian*, "The city of Chicago's procurement services website shows that in March [2012] $757,657 was spent on 8,513 'retro-fit kits' to be fitted to police helmets. In February [2012] 673 of the same kits, which include a face shield and ear and neck protectors, were purchased for $56,632."[85] Plus, the Chicago Police Department announced that it would deploy its two new expensive long-range acoustic device (LRAD) sound cannons, which it had bought for $20,000 each.[86] These were similar to the devices used by the Pittsburgh police to deliver high-pitched alarm tones during the G20 summit meeting there in 2009. There was also the "secret suburban Chicago" police control center where "officials from more than 40 different

agencies sit side by side with a giant central screen before them," as reported by the *Chicago Sun-Times*. From this command center, all different types of federal, state, and local law enforcement could "view live video feeds from security cameras that are already up and running throughout the city."[87]

As one commentator suggested, Chicagoans got to experience firsthand the "new military urbanism in NATO-occupied Chicago"—the "new normal" of militarized security.[88] To be precise and to give a better sense of the extensive nature of these security measures (as reported by the US Secret Service), road closures and pedestrian restrictions during the NATO presence included about 7.5 miles of downtown streets closed off. If one included the posted "intermittent closures," the closed-off length of road went up to about 9.5 miles of central city traffic. And these closures of main travel arteries would last from midnight Friday until rush hour Monday evening—about sixty-five hours. There were also airspace restrictions over Chicago—a no-fly zone with, again I kid you not, "a shoot-to-kill warning for those who break the ban,"[89] as well as marina and waterway restrictions, with the creation of special "maritime security zones" that would be effective and enforced twenty-four hours a day for four days. "The public will see an increased U.S. Coast Guard presence on the water during the NATO Summit,"[90] the authorities warned. This became the new normal. From within, the experience was chilling. As one Chicagoan told the local NBC affiliate, the mass of security equipment "made her feel like she was on 'lockdown.'"[91] It is worth mentioning that this new normal also functions as our new substitute for a welfare state: stimulating the economy, providing piece labor, creating government jobs and subsidized contracts. Here's just one indication: overtime pay for Chicago police officers exceeded $15 million during the NATO summit.[92] Instead of investing in schools and education, job training, or reentry programs, this is how we invest in our future. And we never stop to question that form of government welfare, because it falls in the sacred space

of domestic security—in essence, because of the great American paradox of the laissez-faire police state.[93]

And through all this, the peaceful voices of Occupy and other protests were simply drowned out. They were buried beneath the hype and frenzy of our police state, the legions of black-clad riot police with batons, the images of a few violent clashes, and the frightening images of our new normal urban militarized security.[94] But the voices that were drowned out at Occupy protests—especially Occupy Chicago's anti-NATO protests—were perhaps some of the most moving ones to be heard. "No amount of medals, ribbons, or flags can cover the amount of human suffering caused by this war." "I have only one word, and it is shame." "This is for the people of Iraq and Afghanistan." "Mostly, I'm sorry. I'm sorry to all of you. I am sorry"

In the shadow of the NATO summit, under the watchful eyes of a phalanx of black-clad riot police, dozens of former US servicemen and -women in uniform, veterans of the Iraq and Afghanistan Wars, threw away their medals, with apologies. It was one of the most moving experiences many of us had witnessed in our lives. It is hard to describe. The veterans' words, their voices crackling under the emotion of their courageous act, breaking under the weight of the pain, trauma, anger, sadness, and hope—theirs was a heroic act. Operation Iraqi Freedom Medal. *Tossed.* Global War on Terror Medal. *Thrown.* National Defense Medal. *Pitched.* Marine Corps Good Conduct Medal. *Flung.* Navy and Marine Corps Medal. *Chucked.*

Most of the media reporting of Occupy's anti-NATO protest would focus on the minor violence, on the few clashes, on the blood, on everything that happened *after* the peaceful march was over. In our world of spectacle, the pushing and shoving gets all the attention. It is a pity, because what was truly remarkable was the American servicewomen and -men tossing their medals

back at NATO. In a mixture of sadness, shame, anger, and pride, of trauma, sorrow, and pain—some looking back at their time in Iraq and Afghanistan, some healing from PTSD, others chanting Occupy slogans—these men and women showed a type of courage that the NATO leaders should have been forced to watch. Tragically, our leaders were too busy posing for photo ops and dining in their luxurious gatherings.

"I am returning my medal today because I want to live by my conscience, rather than be a prisoner of it."

"I apologize to the Iraqi and Afghani people for destroying your countries."

"I don't want these anymore."[95]

TO NO LONGER TOLERATE THE INTOLERABLE

"This door was made for you," the gatekeeper said in Kafka's parable. To many people—many of whom came out to Occupy—it felt as if we had been trying to gain entrance for all our lives, to get in and change things for the better. It felt as if we had tried practically everything. We'd argued, canvassed, organized, marched, protested, cajoled, voted, compromised, and, yes, lowered our expectations. We'd tried absolutely everything. To many in the Occupy movement, I believe, the occupation was all about *not* waiting at the door any longer—about no longer being politically obedient.

And if this notion of "political disobedience" has any traction and appeal—and as you can surmise, for me it does—then we will continue to resist the worn-out Cold War ideologies from Hayek to Maoism, as well as all their pale imitations and sequels, from the Chicago School 2.0 to Badiou and Žižek's attempt to shoehorn all political resistance into a "communist hypothesis."[96] We will continue to politically disobey, because the levels of social inequality in this country and the number of children in poverty are intolerable. Or, to put it another way, we will continue to resist conventional politics and faded ideologies

because their outcomes are unacceptable. The Volcker rule, debt relief for working Americans, a tax on wealthy estates—those policy reforms may help in the short term (before they turn into loopholes), but they represent no more than drops in the well of governance and regulations that distribute and redistribute wealth and resources in this country every minute of every day. Deregulation, more regulation, even communism—these terms tell us nothing about how wealth and resources are *really* distributed. Ultimately, what matters to the politically disobedient is the kind of society we live in, not a few policy demands or ideological slogans.

What the future now holds for the Occupy movement is anyone's guess. What comes next is impossible to tell. But one thing is certain. There is no need to hold onto the past. As Jean-Paul Sartre emphasized, or added in his own reading of Kafka's parable: "Each of us, tragically, makes his own door."[97] There's no point in making ourselves another one. No reason to create our own hurdle. Whatever happens to Occupy Wall Street, political disobedience will live on. It will go on and open possibilities.

NOTES

It's been truly inspiring to work with W. J. T. Mitchell, Michael Taussig, and Alan Thomas on this project on the Occupy movement. It has also been an honor and pleasure to work so closely with Thomas Durkin on the numerous legal and political matters that grew out of the movement. In the process, I have learned tremendously from my brilliant, politically disobedient graduate students, especially Chris Berk, Kyla Bourne, Greg Goodman, Irami Osei-Frimpong, Jeremy Siegman, and Kailash Srinivasan. Special thanks to Simon Critchley, Steven Lukes, Arien Mack, Micah Philbrook, Alexander de la Paz, Mia Ruyter, Renata Salecl, David Showalter, Scott Sundby, Jamieson Webster, and Cornel West for conversations and inspiration, and again to Chris Berk for sharing his field notes.

1. This parable, by Franz Kafka, is known as "Before the Law" and was included in chapter 9, entitled "In the Cathedral," of *The Trial* (New York: Schocken Books, 1985), 213–15. I have borrowed from it loosely.

2. This is from the original Adbusters poster, "What Is Our One Demand?" A good site to see the poster is Michael Beirut, "The Poster that Launched a Movement (or Not)," *Observatory*, April 30, 2012, at http://observatory.designobserver.com/feature/the-poster-that-launched-a-movement-or-not/32588/.

3. On the notion of civility, see Bernard E. Harcourt, "The Politics of Incivility," 54 *Arizona Law Review* 345 (2012).

4. Martin Luther King Jr., "Letter from Birmingham City Jail," pp. 289–302 in *A Testament of Hope: The Essential Writings of Martin Luther King, Jr.*, ed. James Melvin Washington (San Francisco: Harper and Row, 1986), at 294 (emphasis added).

5. Occupy Wall Street, http://occupywallst.org. Webtext dated February 5, 2012.

6. David Dewhurst, Peter Dombi, and Naomi Colvin, "How Hayek Helped Us to Find Capitalism's Flaws," *Financial Times*, January 25, 2012, http://www.ft.com/cms/s/0/89d242b0-4687-11e1-89a8-00144feabdco.html. Special thanks to Alexander de la Paz for pointing me to this passage.

7. Slavoj Žižek, "Shoplifters of the World Unite," *London Review of Books*, August 19, 2011. Accessed at http://www.lrb.co.uk/2011/08/19/slavoj-zizek/shoplifters-of-the-world-unite.

8. Sarahana, "Slavoj Žižek Speaks at Occupy Wall Street: Transcript," *Impose Magazine*, October 10, 2011. Accessed at http://www.imposemagazine.com/bytes/slavoj-zizek-at-occupy-wall-street-transcript.

9. Douglas S. Massey, *Categorically Unequal: The American Stratification System* (New York: Russell Sage, 2008).

10. Sabrina Tavernise, "Soaring Poverty Casts Spotlight on 'Lost Decade,'" *New York Times*, September 13, 2011. Accessed at http://www.nytimes.com/2011/09/14/us/14census.html?_r=2&scp=1&sq=poverty%20levels&st=cse.

11. *Id.*

12. Nicholas D. Kristof, "America's 'Primal Scream,'" *New York Times*, October 15, 2011. Accessed at http://www.nytimes. com/2011/10/16/opinion/sunday/kristof-americas-primal-scream. html?_r=1&ref=nicholasdkristof.

13. *Id.*

14. *Id.*

15. Michel Foucault, "Qu'est-ce que la critique?" Lecture delivered May 27, 1978. *Bulletin de la Société française de philosophie* 84:35–63 (1990), at 39.

16. *Id.* at 38.

17. In this regard, I was struck by the *Financial Times* op-ed having the byline "Occupy London" rather than the names of the three members of the economics committee. *See* David Dewhurst, Peter Dombi, and Naomi Colvin, "How Hayek Helped Us to Find Capitalism's Flaws," *Financial Times*, January 25, 2012.

18. Peter Hallward, "Occupy Has the Power to Effect Change," *The Guardian*, November 22, 2011. Accessed at http://www.guardian.co.uk/commentisfree/2011/nov/22/occupy-movement-change.

19. Nicholas D. Kristof, "Occupy the Agenda," *New York Times*, November 19, 2011. Accessed at http://www.nytimes. com/2011/11/20/opinion/sunday/kristof-occupy-the-agenda. html?_r=2.

20. Editorial, "Revolting the Masses," *Wall Street Journal*, November 21, 2011. Accessed at http://online.wsj.com/article/SB10001424052970203699404577044583038468266.html.

21. http://occupywallst.org, Webtext dated February 5, 2012.

22. *Id.*

23. Žižek, "Shoplifters of the World Unite."

24. Michel Foucault, David Cooper, Jean-Pierre Faye, Marie-Odile Faye, and Marine Zecca, "Confinement, Psychiatry, Prison," 178–210 in Michel Foucault, *Politics, Philosophy, Culture: Interviews and Other Writings 1977–1984*, ed. Lawrence D. Kritzman (New York: Routledge, 1990), at 197. In French this interview appears as "Enfermement, psychiatrie, prison," in *Dits et Écrits*, III, no. 209 (Paris:

Gallimard, 1994), 332–60. Thanks to David Showalter for pointing me to this passage.

25. For an interesting discussion of the "human mic" along these lines, see Michael Greenberg, "In Zuccotti Park," *New York Review of Books*, November 10, 2011. Accessed at http://www.nybooks.com/articles/archives/2011/nov/10/zuccotti-park/?pagination=false.

26. Nicholas D. Kristof, "The Bankers and the Revolutionaries," *New York Times*, October 1, 2011. Accessed at http://www.nytimes.com/2011/10/02/opinion/sunday/kristof-the-bankers-and-the-revolutionaries.html.

27. Tom Fiedler, "Occupy Wall Street: How Should It Be Covered Now?," *New York Times*, November 4, 2011. Accessed at http://publiceditor.blogs.nytimes.com/2011/11/04/occupy-wall-street-how-should-it-be-covered-now/?scp=1&sq=occupy%20public%20editor&st=cse.

28. Immanuel Kant, "An Answer to the Question: 'What is Enlightenment?'" (1784).

29. Renata Salecl, *Choice* (London: Profile Books 2010), 19.

30. Occupy Wall Street, http://occupywallst.org. Webtext dated February 5, 2012.

31. Kristof, "The Bankers and the Revolutionaries."

32. James B. Stewart, "Volcker Rule, Once Simple, Now Boggles," *New York Times*, October 21, 2011. Available at http://www.nytimes.com/2011/10/22/business/volcker-rule-grows-from-simple-to-complex.html?pagewanted=all.

33. *Id.*

34. *Id.* (quoting Paul Volcker).

35. Kristof, "The Bankers and the Revolutionaries."

36. Steven Lukes, "Epilogue: The Grand Dichotomy of the Twentieth Century," 602–26 in *The Cambridge History of Twentieth-Century Political Thought*, ed. Terence Ball and Richard Bellamy (Cambridge: Cambridge University Press, 2003), at 612.

37. *Id.* at 612.

38. *Id.* at 618 (quoting Eric Hobsbawm).

39. *Id.* at 618.

40. *Id.*

41. *Id.* at 619.

42. *Id.* at 621.

43. *Id.* at 626.

44. Eli Zaretsky, *Why America Needs a Left: A Historical Argument* (Cambridge: Polity Press, 2012), 15.

45. Catherine Corrigall-Brown, *Patterns of Protest: Trajectories of Participation in Social Movements* (Stanford, CA: Stanford University Press 2012), 16; see also 3.

46. David S. Meyer and Sidney Tarrow, eds., *The Social Movement Society: Contentious Politics for a New Century* (Lanham, MD: Rowman and Littlefield, 1998); Corrigall-Brown, *Patterns of Protest*, 16.

47. Corrigall-Brown, *Patterns of Protest*, 42.

48. *Id.*, 133–34.

49. *What Is Occupy? Inside the Global Movement* (New York: Time Books 2011), 62.

50. Astra Taylor, Keith Gessen, et al., eds. *Occupy! Scenes from Occupied America* (New York: Verso 2011), 40.

51. *Id.* at vii.

52. Writers for the 99%, *Occupying Wall Street: The Inside Story of an Action that Changed America.* (New York: OR Books 2011), 26 [hereafter WF99%].

53. See Michael Taussig, "I'm So Angry, I Made A Sign," in this volume.

54. *Occupy!* at vi.

55. *Occupy!* at 113.

56. *Occupy!* at 39.

57. WF99% at 30.

58. *Id.*

59. Zaretsky, *Why America Needs a Left*, 2.

60. WF99%, 61.

61. Sarah van Gelder and the staff of *Yes!*, eds., *This Changes Everything: Occupy Wall Street and the 99% Movement* (San Francisco: Berret-Koehler Publishers 2011), 45.

62. *What Is Occupy? Inside the Global Movement*, 62.

63. *Occupy!* 193.

64. *Id.* at 132.

65. W. J. T. Mitchell, "Image, Space, Revolution: The Arts of Occupation," in this volume.

66. Dawn Turner Trice, "Soup Is On, in Solidarity with Occupy Chicago: Too Old to Camp Out, Three Hyde Park Women Find Their Own Way to Support Occupy Chicago," *Chicago Tribune*, November 7, 2011. Accessed at http://articles.chicagotribune.com/2011-11-07/news/ct-met-trice-occupy-1107-20111107_1_protest-campaign-senior-citizens-streeterville. Elisabeth Ruyter, my mother-in-law, spearheaded the soup brigade!

67. On that occasion, forty-three senior citizens who stopped traffic by standing or sitting in the middle of a downtown street were escorted away by police officers without being handcuffed, and were merely issued citations to appear in the Department of Administrative Hearings. See "Over 400 Seniors Join Forces with Occupy Chicago at Federal Plaza," *Chicago Sun-Times*, November 7, 2011. Accessed at http://www.suntimes.com/photos/galleries/8674691-417/over-400-seniors-join-forces-with-occupy-chicago-at-federal-plaza.html

68. Bruce Ackerman and Yochai Benkler, "Occupying the First Amendment," *Huffington Post*, October 21, 2011. Accessed at http://www.huffingtonpost.com/bruce-ackerman/occupy-wall-street-first-amendment-_b_1023709.html.

69. Jeff Zeleny, "Obama Weighs Quick Undoing of Bush Policy," *New York Times*, November 9, 2008. Accessed at http://www.nytimes.com/2008/11/10/us/politics/10obama.html?pagewanted=all.

70. Milton Friedman, *Capitalism and Freedom* (Chicago: University of Chicago Press, 2002 [1962]), xiv.

71. "Chicago Police Will Work 12-Hour Shifts during NATO, G8 Summits," *Chicagoist*, January 5, 2012 (accessed at http://chicagoist.com/2012/01/05/chicago_police_will_work_12-hour_sh.php); Tony Arnold, "Chicago Police Union Head: City Not Ready to Host G-8, NATO Summits," WBEZ91.5, June 24, 2011 (accessed at http://www.

wbez.org/story/chicago-police-union-head-city-not-ready-host-g-8-nato-summits-88277).

72. See Substitute Ordinance, Chicago, at www.ward49.com/site/files/322/6327/335275/592046/G8NATOSub.pdf.

73. *Id.*

74. See Andy Thayer, "Latest Versions of Mayor's Anti-Protester Ordinances on the Eve of the City Council Vote," *Chicago Independent Media Center*, January 18, 2012. Accessed at http://dadaarchive.chicago.indymedia.org/newswire/display/95662/index.php.

75. Story at http://www.myfoxchicago.com/dpp/news/metro/policing-plan-security-chicago-g8-nato-summits-protest-fees-backed-off-20120118.

76. Regarding the surveillance, the new ordinance reads: "The superintendent is also authorized to enter into agreements with public or private entities concerning placement, installation, maintenance or use of video, audio, telecommunications or other similar equipment. The location of any camera or antenna permanently installed pursuant to any such agreement shall be determined pursuant to joint review and approval with the executive director of emergency management and communications."

77. Under the ordinance (see page 4), "the Mayor or his designees are authorized to negotiate and execute agreements with public and private entities for good, work or services regarding planning, security, logistics, and other aspects of hosting the NATO and G8 summits in the city in the Spring of 2012 . . . and to provide such assurances, execute such other documents and take such other actions, on behalf of the city, as may be necessary or desirable to host these summits."

78. "MSNBC Reporter Slams NYC Police Brutality! Occupy Wall Street." YouTube, uploaded September 27, 2011. Accessed at http://www.youtube.com/watch?v=meT8CJgEBQw.

79. Cynthia Hodges, "Chicago on Security Lockdown as NATO Summit Approaches" *Examiner.com*, May 18, 2012. Accessed at http://www.examiner.com/article/chicago-on-security-lockdown-as-nato-summit-approaches.

80. Lauren Petty and Jeff Goldblatt, "Security Precautions More Visible Near McCormick Place" *NBC Chicago*, May 17, 2012. Accessed at http://www.nbcchicago.com/news/local/Fencing-McCormick-Place-NATO-151681085.html?dr=.

81. Fran Spielman, "Chicago Police Horses Will Also Get Riot Gear for NATO/G-8 Summits," *Chicago Sun-Times*, February 21, 2012. Accessed at http://www.suntimes.com/news/cityhall/10766037–418/chicago-police-horses-will-also-get-riot-gear-for-natog8-summits.html.

82. See http://www.youtube.com/watch?v=xOiphtwVxnc&noredirect=1.

83. Associated Press, "Cities Sending Officers to Chicago for NATO Summit," May 15, 2012. Accessed at http://www.news-gazette.com/news/courts-police-and-fire/2012–05–15/cities-sending-officers-chicago-nato-summit.html.

84. Paul Street, "The New Military Urbanism in NATO-Occupied Chicago," *The Indypendent*, May 17, 2012. Accessed at http://www.indypendent.org/2012/05/17/new-military-urbanism-nato-occupied-chicago; "NATO Security Crush Driving Chicago Crazy," *The Commercial Appeal*, May 18, 2012. Accessed at http://www.commercialappeal.com/news/2012/may/18/nato-security-crush-driving-chicago-crazy/?print=1.

85. Adam Gabbatt, "Chicago Police Bulk Up With $1m in Riot Gear for 'Peaceful' Nato Summit Protests: Police to Employ Use of Controversial Equipment ahead of Planned Action By a Coalition of Anti-War and Occupy Groups," *The Guardian*, May 11, 2012. Accessed at http://www.guardian.co.uk/world/2012/may/11/nato-protests-chicago-police-riot-gear.

86. Paul Meincke, "Chicago Police Show Off LRAD ahead of NATO Summit," ABC News, May 14, 2012. Accessed at http://abclocal.go.com/wls/story?section=news%2Flocal&id=8661428.

87. Natasha Korecki, "NATO Summit Security Team Has Eyes Open from Secret Suburban Chicago Location," *Chicago Sun-Times*, May 17, 2012. Accessed at http://www.suntimes.com/news/metro/12593763–418/nato-summit-security-team-has-eyes-open-from-secret-suburban-chicago-location.html.

88. Paul Street, "The New Military Urbanism in NATO-Occupied Chicago."

89. "No-Fly Zone to Be Enforced by Shoot-to-Kill Order during NATO Summit," CBS Chicago, May 2, 2012. Accessed at http:// chicago.cbslocal.com/2012/05/02/no-fly-zone-to-be-enforced-by-shoot-to-kill-order-during-nato-summit.

90. "Security Plan Shuts Down Roads, South Loop for NATO Summit Weekend," CBS Chicago, May 4, 2012. Accessed at http:// chicago.cbslocal.com/2012/05/04/security-plan-revealed-for-nato-summit-weekend/.

91. Lauren Petty and Jeff Goldblatt, "Security Precautions More Visible Near McCormick Place."

92. David Heinzmann and Jeff Coen, "Chicago Police Racked Up $15M in Overtime Costs for NATO Work: City Seeking Reimbursement from Federal Government, Summit Host Committee," *Chicago Tribune*, June 30, 2012. Accessed at http://www.chicagotribune.com/news/local/ct-met-nato-police-overtime-630-20120630,0,942758.story.

93. Bernard E. Harcourt, "On the American Paradox of *Laissez Faire* and Mass Incarceration," 125 Harvard Law Review Forum 54 (2012). Accessed at http://www.harvardlawreview.org/issues/125/march12/forum_838.php.

94. For a photo essay at *The Guardian*, see Isadora Ruyter-Harcourt, "Chicago and NATO: Police State in 2012?" at http://www.facebook.com/media/set/?set=a.461756157184790.124189.45674021 7686384&type=1#!/photo.php?fbid=461763420517397&set=a.46175 6157184790.124189.456740217686384&type=3&theater.

95. You can listen to these men and women at the *Digital Journal*; see Anne Sewell, "Op-Ed: Veterans Throw Away Medals in Chicago Anti-NATO protest," May 20, 2012. Accessed at http://www.digitaljournal.com/article/325215#ixzz20umbJONT.

96. Alain Badiou, *L'hypothèse communiste* (Paris: Nouvelles Éditions Lignes 2009).

97. Jean-Paul Sartre, *L'être et le néant: Essai d'ontologie phénoménologique* (Paris: Gallimard, 1943), 609. My translation.

IMAGE, SPACE, REVOLUTION

THE ARTS OF OCCUPATION

W. J. T. Mitchell

In the fall of 2011, I received two invitations to speak on the global Occupy movement. The first was from the Supreme Council of Culture in Egypt, asking if I would come to Cairo for the first anniversary of the January 25 revolution that led to the downfall of the authoritarian regime of Hosni Mubarak. The invitation (now postponed indefinitely, given the uncertain state of the revolution), stipulated that I should reflect on "the role of images and media in the 25th January Revolution and the Occupy Wall Street movement." The second was from a relatively quieter part of the Arab world, namely Morocco, where I was invited by a new art space called Dar al-Ma'mun to give a keynote address on "art and the public space" at the Marrakech Biennale.[1] The invitation asked that I "engage with the images of the Arab Spring that have circulated in the past year, noting that "those images and the apparatuses through which they have circulated played a huge part in the events." It went on to suggest that "we are missing a convincing analysis" of these images, "and we are at a loss when it comes to 'organizing' them theoretically." The invitation concluded with a provocation to pose the remarks around a pair of questions: "What Did Pictures Do?" or "Can Images Revolt?"

Needless to say, I found these invitations both terrifying and

irresistible. The terror was not based in fears for my personal safety in either of these places, but in the sense of my own inadequacy to the task of reflecting on the momentous events of 2011. Isn't there something faintly ridiculous and presumptuous about writing in the midst of a revolution, when the whirlwind of events sweeps away one's words the moment they are written? At best, one could hope to wind up like "poor old Marat," dead in his bath while terror rages on.

The thing that made these invitations irresistible, aside from the prospect of visiting places that until now have existed for me only as images, was that they formulated for me precisely the questions I had been asking myself. What role *did* images and media play in the revolutions of this remarkable year? What specific images and media emerged as the most potent and memorable? Why did the tactics and rhetoric of "occupy" emerge so centrally in so many diverse places? And is there a larger framework for understanding the shape of events in the Arab Spring and Occupy Wall Street that can be glimpsed in the images of this revolutionary year?

WAS THIS A REVOLUTION?

> The modern concept of revolution, inextricably bound up with the notion that the course of history suddenly begins anew, that an entirely new story, a story never known or told before, is about to unfold, was unknown prior to the two great revolutions at the end of the eighteenth century.
>
> HANNAH ARENDT, *On Revolution*[2]

> Occupy Wall Street is politically disobedient to the core—it even resists attempts to be categorized politically. The Occupy movement, in sum, confounds our traditional understandings and predictable political categories.
>
> BERNARD E. HARCOURT, "Political Disobedience"

Obviously this is an overwhelmingly difficult set of questions, most of which I will have to beg in the following pages—or at least I will have to beg forgiveness for providing only partial answers. To begin with, did the events of 2011 constitute a revolution at all? What exactly is a revolution? What are the criteria, the essential features? The sheer diversity of events across the Arab world, many of which are still in progress, renders any claim of certainty ludicrous. Tunisia, Egypt, Syria, Libya, Yemen: the specificity of these situations makes general claims impossible. Yet when the contrast is made between the Arab Spring and Occupy Wall Street, a certain set of distinctions does come into focus. The first is the question of political aims. The Arab Spring was primarily about democracy and the overturning of authoritarian regimes, while Occupy Wall Street was directed at the global center of finance capital. OWS was concerned with the corruption of democracy by drastic economic inequality, but it did not aim at regime change or target a tyrannical individual. In fact, OWS owed a great deal to the inspiring hopes (and angry disappointment) raised by the 2008 election of Barack Obama; its primary target was the global economic system symbolized by Wall Street, rather than any specific individual.

The second issue is the question of scale. In the Arab Spring, the tactical mix of violent uprising and nonviolent assembly varied considerably from one country to another, but the iconic spectacles that circulated in global media were clearly centered on the mass gatherings and occupation of Cairo's Tahrir Square. OWS, by contrast, involved relatively small gatherings in a comparatively small space, the tiny public-private plaza of Zuccotti Park in lower Manhattan. The crowds in Tahrir Square reached into the millions; Zuccotti Park at its peak drew crowds of ten to twentythousand people. The violence in Zuccotti Park was, compared to that in Cairo and other Arab capitals, relatively minor.

But these comparisons of scale can be misleading if they are taken as keys to the relative importance of these events.

Zuccotti Park may be a small place, but as images of Occupy Wall Street went viral in the global media, the park began to take on the look of a revolutionary space. As Occupy events metastasized in scores of cities across the United States, the repetition of militarized police violence—the clubbing, pepper-spraying, and shooting of nonviolent demonstrators—expanded the perceived magnitude of OWS into a national movement. When linked, as it obviously was, to the series of events inspired by the Arab Spring—from the occupation of the state capitol in Madison, Wisconsin, to the tent city in Tel Aviv, to the street riots of the "English Summer" in London—Occupy Wall Street seemed to many the culmination of a global process. And crucial to the question of scale was the sense that the physical size of crowds and the magnitude of spaces, while important, was not the sole determinant of importance. Equally crucial was the question of the *image*, both verbal and visual, and its potency as a multiplier of meaning, power, and emotion. This is not to suggest that images were the "cause" of the revolutions of 2011, so much as to recognize that they can, under the right conditions, serve as catalysts to set off a chain reaction of mass emotion out of all proportion to their physical size or importance. Thus, everyone who has reflected on the cycle of events in this revolutionary year recognizes that it was the solitary act of a fruit vendor in Tunisia who immolated himself to protest against harassment by corrupt police officials that "set off" the Arab Spring. And it should be noted that in a very real sense this is not a visual but a verbal image—a description of an event, a scene, that merely has to be mentioned to stir a sense of outrage. Like the infamous Danish cartoon caricature of Muhammed that incited violent reactions throughout the Arab world, the image of the Tunisian fruit vendor did not need to be seen. One only had to hear about it.

The alert reader will notice that I still have not addressed the truly crucial question: Were these events revolutions at all? The Arab Spring, insofar as it centrally involved regime change and

more or less violent uprisings of populations against the state, certainly seems to qualify. Of course, that does not mean that these were all successful revolutions. The very notion of "success" is highly debatable; no revolution in human history has been an unmixed success, and one could argue that the normal course of the revolutionary process is one of high hopes ending in some degree of betrayal. The canonical revolutions of the modern era—the French, Russian, and Chinese—were abject failures from the standpoint of democratic ideals. The American Revolution may have succeeded, as Hannah Arendt argues, only because it was sustained by very special material conditions—the widespread prosperity of a breakaway settler colony engaged in the conquest and exploitation of native lands and the expulsion of indigenous peoples; a slave economy in the southern colonies; a voracious appetite for new immigrant labor.[3] And the "success" of the American Revolution, insofar as it was premised on ideals of democracy, freedom, and equality, is exactly what has come into question in the Occupy movement.

Categorical certainty about the kinds and qualities of the revolutionary moment we now inhabit, then, needs to be suspended in favor of an openness to the variety of forms of revolution. Syria may have to pass through the ordeal of a civil war before it accomplishes the minimal goal of overturning its dictator. Libya has eliminated its dictator, but the nature of the regime that will take his place is still uncertain. Egypt's revolution, for many of those who took part in the events of January 25, 2011, is now being betrayed, first by an unholy alliance, and subsequently by an uneasy standoff between the Muslim Brotherhood and the remnants of Mubarak's military regime.

Nevertheless, it would seem impertinent to question whether the events of the Arab Spring were revolutionary in their aims and methods. Can the same be said of Occupy Wall Street? I think we would have to admit that OWS falls somewhat short of being a revolution, for reasons I have already spelled out. The crucial feature of regime change is not even in question. And in

fact, it might make sense to draw a distinction between a revolutionary *event* and a revolutionary *language*, as Ariella Azoulay has proposed.[4] The former certainly must include the latter, but not the reverse. Revolutionary language, at its most debased level, would be covered under the old saying, "talk is cheap." A real revolution is a historical event. It may be a failure; it might be betrayed by a counterrevolution. But material and social conditions have to undergo, we suppose, a substantial change for a revolution to count as the real thing. The main effect of Occupy Wall Street has been, by almost universal consensus, to "change the conversation." And this change was anything but radical. It involved a shift in the dominant political discourse from talk about government spending and the deficit to unemployment and inequality. While this shift is important, it hardly seems like a revolution.

And yet, something in the Occupy movement *feels* like a revolution to many of the people who participated in it, or who merely observed it from the sidelines. Is this feeling merely sentimental? Or is it grounded in something more substantial—perhaps a revolutionary historical *process* or *moment* rather than a singular event? And who is to say that revolutionary events exist in some kind of special domain that is distinct from feeling and change in the conversations people are having? Perhaps Occupy Wall Street is not so much a revolutionary event as an image or an echo of one—which would not be to dismiss it as unreal or unimportant, but simply to identify the level of reality that it occupies.

For at the level of the imaginary, which is to say the level of media spectacle and widely shared images of reality, the revolution of our moment did not begin on September 17 with the Adbusters call to Occupy Wall Street. It had already begun in the United States with the iconography of the Tea Party, and the effort to stage a populist and nationalist revival around images of the original American Revolution. The contemporary restaging of revolution was, of course, grounded, as most revolutions

must be, in a popular *reaction* to a widely perceived injustice: the bailout of Wall Street in the election season of 2008. This is one of the key issues that the left and right agree upon in this season of imaginary revolutions. All sides, at least for a passing moment, hated Wall Street and identified with the 99 percent. It's just a different 99 percent for the Tea Partiers, whose image of the American Revolution is, on the one hand, of a prosperous white polity like that of the Founding Fathers, in which people of color and slavery are rendered invisible; and, on the other hand, of a call for regime change and the overthrow of the state, as in the Arab Spring. We must not forget the rhetorical images that reigned in the Tea Party's "change of the conversation." Obama was declared to be a tyrant. There were dark sayings about Second Amendment solutions and watering the tree of liberty—Jeffersonian code for assassination of the president as a revolutionary act. The Tea Party displayed, in Slavoj Žižek's phrase, "authentic *political* passion" in its declaration of universality and its insistence on radical division of friend and enemy.[5]

But the division in US politics went even deeper than that. The racist images of Obama produced by the Tea Party depicted not just an American tyrant but an upstart Negro, an illegal immigrant, and (what a coincidence!) a Muslim tyrant and terrorist. Obama, portrayed as secret Muslim, illegal African immigrant, and "uppity Negro," was cast in the role of the enemy in a racial and religious war. And there were materials to fuel the Tea Party's paranoid fantasies. It was no accident that Obama's first visit to the Middle East featured a memorable speech in Cairo, and that this speech was among the positive catalysts for the Arab Spring. The election of Obama was, for both his supporters and his opponents, something of a revolutionary moment. At the level of the visual imagery of race, it was clearly a breakthrough that would have been unimaginable a few years earlier. At the level of the poetic and acoustic image, it amounted to the election of a figure who synthesized the proper names of the principal enemies of the United States in the preceding

period: "Barack Hussein Obama" fuses and confuses the names of Saddam Hussein and Osama bin Laden. The latter became clear when, on the occasion of bin Laden's assassination on May 1, 2011, broadcasters all over North America were unable to stop themselves from talking about the death of *Obama* bin Laden. Fox News even managed to produce a graphic headline declaring "Obama bin Laden Dead."[6]

The mirror image of this fantasy of Obama as Black Muslim was the leftist hope that Obama was a revolutionary radical whose administration would root out the criminal behavior of the Bush administration. One way you can tell whether a political shift is an authentic revolution (in Žižek's terms) is if the leaders of the displaced regime are placed on trial. One waited in vain for Karl Rove, Donald Rumsfeld, and Dick Cheney to be charged with war crimes and crimes against humanity. It was signaled early and often in Obama's campaigns that it would do nothing of the kind—that it would be a "soft" revolution that looked forward, not backward.[7]

Obama is, as the reality-based community knows, anything but a radical revolutionary. He is a neoliberal, moderate Democrat who has been all too eager to compromise with his reactionary opponents, and who has only slowly come to realize that they are authentically political in their single-minded desire to destroy him. But Obama is a master of images and rhetoric as well, and he nurtures the myth of the American revolutionary ideal in his speeches. He consistently appeals to the history of the American experiment as an incomplete revolution that is struggling toward "a more perfect union."

To return to our initial questions: What sort of revolutions took place in the year 2011? In the Arab Spring, there occurred a series of "hard" revolutions of the classic form. In the United States, Occupy Wall Street continued a "soft" revolution that continued a process that had begun with the election of Obama, whose 2012 State of the Union address echoed many OWS demands. But there is a curious mirroring between the hard and

soft revolutions that characterizes this global moment. The hard revolutions of the Arab Spring, which ask for not much more than democracy, civil liberties, and a decent Keynesian economy, turn out to be the inspiration for an American imitation that takes on the very center of American capitalism. While moderate and restrained in its tactics (nonviolent occupation of public spaces), Occupy Wall Street is radical in its demands and, some would say, even more radical in its refusal at the outset to be pinned down to any specific demands. This is something it had in common with Tahrir Square, with its conspicuous insistence on an anti-iconic, nonsovereign image repertoire. Tahrir Square may have opened a Facebook account, but it refused to have a representative *face* come forward as the avatar of the revolution. This was partly tactical, of course, for if the police had been in possession of such a face, they would have quickly arrested and tortured the body connected to it. But it was also a key ideological feature of the Occupy movement, which insisted on an iconography of nonsovereignty and anonymity, renouncing the face and figure of the charismatic leader in favor of the face in and of the crowd, the assembled masses. When faces did emerge, they were of indefinitely repeatable *masks*, such as the grinning visage of Guy Fawkes, a singularly awkward and inappropriate icon of a nonviolent revolution.[8]

OCCUPATIO

The iconic moments, then—the images that promise to become monuments of the global revolution of 2011—are not those of *face* but of *space*; not figures, but the negative space or ground against which a figure appears. The only figure that circulates globally, that embraces both Tahrir Square and Zuccotti Park, is the figure of *occupation* itself. But occupation and the Occupy movement have no definite form or figure other than the dialectical poles of the mass and the individual: the assembled crowd and the lone, anonymous figure of resistance. And occupation,

it should be noted, is not only a visual and physical presence in a space, but a discursive and rhetorical operation. It is directly linked to the trope of *occupatio*, the tactic of anticipating an adversary's arguments by preempting them, taking the initiative in a space where one knows in advance that there will be resistance and counterarguments.[9] In the context of the rhetoric of public space, *occupatio*, as the etymology of the word reveals, is the "seizure" of an "empty" place: one that is supposed to be *res nullius*, not owned by anyone, not private property. It is a demand in its own right, a demand for *presence*, an insistence on being heard and seen before any specific political demands are made, and that the public be allowed to gather and remain in a public space. But the demand of *occupatio* is made in the full knowledge that public space is in fact "preoccupied" by the state and the police, that its "pacified" and democratic character, apparently open to all, is sustained by the ever-present possibility of violent eviction.[10] *Occupatio* thus aims not just at taking possession of an empty space in an argument, but also at provoking a response and framing it in advance.

Equally important to the positive meaning of *occupatio* as the "seizure" of empty space is its negative role in the *production* of an empty space that is paradoxically a space of fullness and plenitude. This version of *occupatio* is typically characterized as a refusal to say something while at the same time saying it. It can be based in the speaker's inadequacy or in the insufficiency of the medium itself—as in Wordsworth's declaration that "I cannot paint / What then I was," followed by an outpouring of description. Laurence Sterne's *Tristram Shandy* literalizes in graphic form the trope of *occupatio* in his confession of his inability to describe the magnificent beauty of the Widow Wadman. Sterne follows this confession with a blank page that he invites the reader to fill in.

The Occupy movement is a dramatic performance of the rhetoric of *occupatio*. It refuses to describe or define in any detail the world it wants to create, while showing this world in its ac-

tual presence as a nascent community. It renounces the demand that it make specific, practical demands, while opening a space in which innumerable demands can be articulated. And it does so not so much as a declaration of inadequacy ("We are unable to say what we want") or as a principle of refusal, but as a deliberate deferral ("This is not the time to make policy statements; our presence here is in itself a statement more fundamental than any policy"). This strategic refusal to speak is displayed in a number of familiar tactics: for instance, the silent vigil performed by the Buddhist contingents that sometimes accompany Occupy; the wearing of gags or tape over the mouth to visibly perform the suppression of free speech and assembly; the "mic check" tactic, which both amplifies speech and exposes its curtailment by police forces that prohibit the use of amplification. These tactics are linked to the overall strategy of refusing to designate representatives or "spokespersons," and more generally to the insistence on staging a politics of radical equality and nonsovereignty. The aim, in other words, is not to seize power but to manifest the latent power of refusal (cf. the general strike) and create the foundational space of the political as such—what Hannah Arendt calls "the space of appearance"[11] that is created when people assemble to speak and act together as equals, without representatives or delegates. This space is foundational because it precedes politics in the usual sense of parties, leaders, and policies, constituting a potentially revolutionary and constitutive site of assembly, speech, and action.

The trope of *occupatio*, then, involves a paradoxical temporal and rhetorical dimension. It speaks by refusing (for now) to speak; it declares by refusing to declare; it endures and prolongs a silence and a temporary "holding action" that will inevitably be succeeded by more speech and action. The Occupy movement and the figure of *occupatio* thus constitute the verbal-visual image that unites the revolutionary movements from the Arab Spring to Occupy Wall Street. OWS was inspired not by the Arab Spring's objective of overturning dictatorships and estab-

lishing democratic regimes, but by its strategic deployment of the rhetoric of space and the tactics of occupation.

It should be clear, then, why it was the Occupy movement that went viral globally, and not any of the specific demands. Occupy was capable of reconciling—or at least providing a common place for—innumerable contradictions. In Tahrir Square the Muslim Brotherhood camped next to Coptic Christians, radical fundamentalists, secular liberals, and Marxist revolutionaries. Right-wing Zionist settlers joined the anti-Zionist ultra-orthodox along with secular Jews and even a few Palestinians on Rothschild Boulevard in Tel Aviv, and Tea Partiers showed up at Occupy rallies across the United States. The very word "occupy" performed a kind of homeopathic magic on the discourse of globalization and, indeed, on discourse as such. As an imperative (*"you* occupy") it constituted a universal address to any conceivable addressee; it interpellated or "hailed" (to recall Althusser's formulation) the whole world and every potential subject of address. As a transitive verb it could take direct objects ranging from highly specific places (Tahrir Square, Wall Street) to the entire world. Occupy would ultimately seize even abstract, conceptual objects as well: time, theory, the disciplines, the arts, the imagination, the media, the United States, everything. A poster with the words "Occupy Everything" spelled out the unlimited scope of this figure, illustrating it with a pie chart that was 99 percent black, with a tiny wedge of white signifying "the 1 percent" that actually occupies most of the world's wealth. At the same time, the word "occupy" was mutating out of its verbal function into a noun and an adjective, as if it were occupying language itself. There was the term "Occupy movement," which made "Occupy" an adjective modifying movement, and there was the simple act of using "Occupy" as the subject of a sentence in place of the nominative "occupation": "Occupy has come to Oakland." Occupy thus became a capitalized proper noun, the brand name of a movement.

Aside from its unlimited grammatical flexibility, Occupy

performed an uncanny repetition and parodic mimesis of a preexisting condition: namely, the occupation of the world by a global system that has oppressed and impoverished the vast majority of the world's population and destroyed the environment at the same time. The clearest symptom of the uncanny reversal in the meaning of the word "occupation" has been the transformation from its principal meaning in the last historical epoch as a label for military conquest and neocolonialism: the invasion and occupation of Iraq and Afghanistan, the propping up of authoritarian regimes across the Middle East, the half-century-long occupation of Palestinian lands by the state of Israel. For years, many of us have been thinking of occupation primarily in these terms: as the imposition of martial law on a resistant population, the proliferation of dictatorships in the name of resistance to communism (or fundamentalism, or terrorism), and the fostering of "freedom" (for markets and speculative capital, not for human beings). But now, suddenly, the word "occupation" has taken on a new meaning: the reclaiming of public space by masses of disenfranchised people; the peaceful, nonviolent seizure of places in an effort to provide a new beginning; a foundational space for justice, democracy, and equality.[12]

The world was waiting for just such a counter-occupation. It was not enough to call for a demonstration, a parade, or a temporary gathering. The difference between demonstration and occupation, and the arts specific to each, is significant. The sit-ins of the American civil rights movement were not merely demonstrations; they were gestures of occupation, declarations that the racial segregation of public spaces would no longer be tolerated. Occupation is, in addition to its spatial connotations, an art of duration and endurance, manifesting the paradoxical synthesis of social *movement* and *mobilization* with *immobility*, the refusal to move. It is a movement whose central declaration is, as the classic protest song puts it, "We Shall Not Be Moved." It presumes the long campaign, the revolution, as a lengthy pro-

cess and a new language that keeps renewing itself. The revolution is not an event that is over and done with, reducible to a date on the calendar. It is a *job*, an occupation: as one poster put it, "I lost my job but found this occupation." It is also a historical process punctuated by "moments"—turning points, tipping points. It is therefore signaled not just by the massive gathering of people, but by the tiny moments, the seemingly insignificant catalytic events: a Tunisian fruit vendor immolating himself; a lone activist camping in Parliament Square for ten years.[13]

IMAGE, SPACE, REVOLUTION

> Action and speech create a space between the participants which can find its proper location almost any time and anywhere. It is the space of appearance in the widest sense of the word, namely the space where I appear to others as others appear to me The space of appearance comes into being wherever men are together in the manner of speech and action, and therefore predates and precedes all formal constitution of the public realm . . . unlike the spaces which are the work of our hands, it does not survive the actuality of the movement which brought it into being, but disappears not only with the dispersal of men . . . but with the disappearance or arrest of the activities themselves.
>
> HANNAH ARENDT ("H" 198–99)

Against the background of occupied spaces such as Tahrir Square and Zuccotti Park, what images emerge as the iconic figures? Insofar as these events involved an intent to *occupy* rather than to merely *demonstrate* and go home, one might single out the image of the *tent* and the encampment—the sign that these were not temporary or transitory gatherings like the typical political rally, but manifestations of a long-term resolve. The message of the tent is that the demonstration is here to stay, that it has seized the public space and will not relinquish it until its demands are met. Along with tents, of course, came all the prac-

tical signs of dwelling and a functioning village: in tiny Zuccotti Park, as in Tahrir Square, medical facilities, food services, libraries, clothing dispensaries, and communication centers sprang up. These scenes were in some ways a positive mirroring of that other form of the encampment which has become so ubiquitous on the world stage: the shantytowns and improvised refugee camps that spring up wherever a population finds itself displaced, homeless, or thrust into a state of emergency. In the wake of the Arab Spring, one even found tent cities springing up all over Israel, from fashionable Rothschild Boulevard in Tel Aviv to mixed Jewish-Arab areas south of Jaffa.[14]

These encampments and gatherings, however, quickly became the background or negative space against which a bewildering variety of verbal and visual images could be staged. So a further question arises: What positive images will remain as the enduring icons of the global revolution of 2011? What monuments will commemorate the series of democratic insurgencies that swept the world from the self-immolation of a fruit vendor in Tunisia to the occupation of Tahrir Square to Occupy Wall Street?

The massive outpouring of creativity during this year of crisis—the millions of images conveyed in banners, slogans, videos, photographs, posters, costumes, and performances—would seem to render a comprehensive, much less systematic, account impossible. The speed and vast archival capacities of digital media render this material hyperaccessible to searching and retrieval, while at the same time threatening to drown the researcher under a tsunami of material.[15]

One can glimpse at the outset, however, a certain dialectic between images of triumphal defiance and joy, on the one hand, and images of abjection, humiliation, and police violence on the other. Positive icons—such as the Adbusters ballerina dancing on the Wall Street Bull, the face of the anonymous revolutionary multitude embodied in the mask of Guy Fawkes, a wedding in Tahrir Square, or simply the assembled masses united in fes-

tivals of democratic exuberance—will no doubt survive. But equally important will be the journalistic photos and videos capturing the outrageous violence against nonviolent demonstrators: the cavalry assault on Tahrir Square, and the pepper-spraying of nonviolent protestors in Oakland, Berkeley, and Zuccotti Park. One might take the Ballerina on the Wall Street bull and the Woman with the Blue Brassiere being stripped and stomped by Egyptian police as emblematic of the fundamental polarities of the Occupy movement: its positive aim of taking back public space for the people, and its negative aim of exposing the systematic violence that has been concealed under the veil of "public safety," "stability," and "security." The fact that both these iconic images are centrally focused on women is no accident, for the whole tactic of nonviolence has an inherently feminine and feminist connotation, in striking contrast to the macho violence it elicits. (This is a tradition that goes back to *Lysistrata* and restraint of male violence by women.) The Ballerina does not try to kill the bull; she turns him into a support for her performance. The Woman with the Blue Brassiere does not fight back, but compels the police to play their part in the tableau of active nonviolence. Like Martin Luther King Jr. confronting the fire hoses and police dogs of "Bull" Connor in Birmingham, Alabama, the Ballerina and the Woman with the Blue Brassiere are performance artists.[16] One is virtual, imaginary, and spectral—a figure who defies gravity and material constraints, most vividly in her holographic reincarnation by OccupyCinema.org, dancing atop the real Wall Street bull after the actual Occupy encampment had been evicted. The other is all too actual and real—not just a symbol, but a flesh-and-blood human being who becomes virtual and goes viral.[17]

While these images and many others will remain iconic of the global Occupy movement, however, I do not think they will be the monuments of the revolution of 2011. Images can only come alive against a background. Every figure requires a ground, a landscape or environment in which it can appear and

move. For the truly enduring monuments to revolution, I think we must follow the lead of Michelet's famous analysis of the French Revolution, and his declaration that *empty space* and the specific place where the major events of the revolution occurred are its true monument.

> The Champ de Mars! This is the only monument that the Revolution has left. The Empire has its Column, and engrosses almost exclusively the Arch of Triumph; royalty has its Louvre, its Hospital of Invalids; the feudal church of the twelfth century is still enthroned at Notre Dame: nay, the very Romans have their Imperial Ruins, the Thermae of the Caesars!
>
> And the Revolution has for her monument: empty space.[18]

The Champ de Mars, originally a military parade ground, became the site of both the celebrations and the catastrophes of the French Revolution, beginning with the first Bastille Day on July 14, 1790, followed a year later by the National Guard's massacre of citizens who had gathered to sign a petition demanding the removal of the king. It was also the site of the first attempts to monumentalize the revolution, including Jacques-Louis David's Festival of the Supreme Being in 1794, featuring an artificial mountain with a "Tree of Liberty." It was also the place where the first mayor of Paris was guillotined.

For Michelet, however, none of these images or events remains as the iconic monument to the French Revolution. Michelet insists that the "only monument" is the "empty space" of the Champ de Mars. I want to propose that a similar logic is at work in the revolutions of 2011. The scores of plazas, squares, and open urban spaces around the world from Tahrir Square to Zuccotti Park are themselves the appropriate monuments to the Occupy movement. Despite the many differences in history and specific architectural design, these places have in common their emptiness, and their function as what Heidegger called a "clearing": an opening in the city's dense fabric, and thus a

place of "gathering." Their emptiness is a register of their historical character as what Hannah Arendt called "the space of appearance" where shared political speech and action occurs, and which can vanish into a ghostly memory "with the disappearance or arrest of the activities themselves."

The other thing that unites these places is the temporality of contagion, the way in which the empty spaces of public gathering became a kind of global commons, thanks to the contemporary phenomenon of cyberspace and its linkage to the mass media. The empty space of contemporary revolution is thus really a threefold space comprised of (1) bodily immediacy, site specificity, and intimate proximity, epitomized by the "mic check" or "people's microphone," which recalls Jean-Jacques Rousseau's famous declaration that the foundational scene of democracy is the assembled mass addressed by the sound of the human voice; (2) the extended social space made possible by social media such as Twitter, Facebook, YouTube, and e-mail; and (3) the amplification and reproduction of the social media by mass broadcast media. Actions taken in Tahrir Square are thus echoed in Madison, Wisconsin, in Zuccotti Park, all over the Arab world, and beyond. Indeed, the great Enlightenment revolutions involved precisely the same structure of mediation, despite the vast differences in their technical bases. The French Revolution was not only a process of assembling the masses in the real spaces of Bastille and the Champ de Mars; it was also a virtual, mediated process. As William Hazlitt noted, the revolution was "a remote but inevitable result of the invention of the art of printing'" Thomas Carlyle summed up the revolutionary era as "the age of paper."[19] Corresponding societies and postal services provided the structural equivalent of contemporary social media, and the unlicensed printing of pamphlets and broadside declarations occupied the new empty spaces of print culture.[20]

Of course, nothing guarantees that these negative, empty spaces, whether actual or virtual, will remain democratic sites, much less revolutionary ones: the Champ de Mars was a mili-

tary parade ground, and the place where the French Revolution degenerated into an orgy of violence. The militarized response to the various occupations of public space in the United States was coordinated in teleconferences with the mayors of at least twenty American cities.[21] The commons is not an empty space that is simply free for the taking, but a battleground where the possibility of democracy and revolutionary change is contested.

We need to interrogate further, then, the notions of the monumental image and empty space. Our usual picture of the monument is of a statue or obelisk erected in empty space. But Michelet pushes in just the opposite direction, suggesting that the monument is not the figure, but the ground; not the statue, but the empty space without the statue. Why? What exactly do we mean by "empty space," and how does it become monumentalized?

The first thing to reiterate is that empty space is not necessarily a monument to democratic revolution. It may just as easily serve as a monument to totalitarianism, whether or not it is ornamented by the statue of a dictator. The urban renewal of Paris by Haussman in the nineteenth century was famously a strategy of state control and of "clearing," opening long, wide boulevards, such as the Champs-Elysees, that would offer few opportunities for the erection of revolutionary barricades and serve as unobstructed firing ranges for artillery to suppress popular uprisings. Red Square in Moscow and Tiananmen Square in Beijing have served as staging grounds both for popular protest and for spectacles of absolutism. The famous image of the lone individual confronting a column of tanks in Tiananmen Square captures this duality perfectly.

So "empty space" is, unsurprisingly, a radically ambiguous and polyvalent form of what Henri Lefebvre called the "production of social space." In urban environments it is the "space between" the buildings; that is, the streets, parks, and plazas that provide the setting for parades, encampments, and public gatherings to celebrate or protest the state. It is important to see,

then, that not all empty spaces are empty in the same way. Some are "emptied" or "cleared" by neglect and abandonment, the vacant lots and houses that accompany economic hard times, or by police violence against crowds, mobs, assemblies, and encampments. Tahrir Square under the Mubarak regime was not a popular gathering place; in fact, it had been fenced off for many years with the excuse that it was a construction site for a planned underground parking garage. As Nasser Rabbat notes, "Tahrir Square . . . is a densely layered territory in which the modern meets the Mamluk, Haussmanian vistas meet cold-war brutalism, and networked paths meet the open agora."[22]

Empty space could be a sign of defeat, of a revolution suppressed, defeated, or betrayed; a revolution that left nothing behind, that changed nothing, that has come to nothing. Or it could be a space taken over by a monument to a living sovereign, the nearest thing we have to an idol in contemporary culture. The figure of the tyrant—the Dear Leader, Chairman, Führer, or Leviathan—takes dominion over the empty space of the public square, the plaza, the park, or the agora, and pretends to incorporate within itself the assembled collectivity, as a personification of the people and popular will. The empty space then is haunted, populated by spirits that refuse to rest, collective and individual memories; a perception that leads toward an opposite reading of the empty space, and its transformation into a sign of potentiality, possibility, and plenitude, a democracy to come, with the empty public space awaiting a new festival and renewed occupation—a new "space of appearance."

Recent leftist political theory has compulsively returned to the image of empty space as the foundational figure of democracy itself. The Jeffersonian idea of democracy as perpetual revolution is coupled with the idea that formal democracy, in the form of election cycles, requires that the place of sovereignty and power remains empty in principle (but certainly not in practice). The important thing is the office, not the flesh-and-blood occupant. Žižek's critique of formal democracy, for instance,

accuses it of a kind of liberal fundamentalism that systematically erases and ignores the underlying violence of capitalism: "Insofar as we play the democratic game of leaving the place of power empty, of accepting the gap between this place and our occupying it, are we—democrats—all not . . . faithful to castration?"[23] Žižek himself is quite faithful to this metaphor. He goes on to argue that liberals, with their ideologies of tolerance, inclusion, multiculturalism, and faith in the democratic process, do not "have the balls to try the impossible" (*Violence*, 177)—which would be, of course, to overturn the global system of capitalism that democracy reinforces and sustains.[24] He expresses a guarded admiration for the intransigence of the Republican Party, noting that "it is only right-wing populism which today displays the authentic *political* passion of accepting the *struggle*, of openly admitting that, precisely insofar as one claims to speak from a universal standpoint, one does not aim to please everybody, but is ready to introduce a *division* of 'Us' versus 'Them.'" (*Ticklish Subject*, 210; quoted in Dean, 5) For Žižek, the only true basis of politics is the claim to universality (and thus total revolution), coupled with a political practice that divides rather than unites, renouncing any notion of compromise or negotiation as a liberal ruse that simply preserves the unchallenged hegemony of capital. One sees here the convergence of Karl Rove's basic political philosophy with Leninism, and the revolutionary authenticity of the Tea Party.

Žižek also dismissed the festive aspect of Occupy Wall Street as a distraction from the serious business of revolution. "Don't fall in love with yourselves, with the nice time we are having here. Carnivals come cheap."[25] I remember hearing this same homily preached in the Sixties. I thought it was a mistake then and still do. I want to insist on the need for exuberance, creativity, and pleasure in the revolutionary process. Emma Goldman captured the point perfectly when she declared that she did not want to be part of any revolution that banned dancing. I would add drumming.[26]

THE ARTS OF OCCUPATION

The remarks on art, space, and their interplay remain questions even if they are uttered in the form of assertions. These remarks are limited to the graphic arts, and within these to sculpture. Sculptured structures are bodies. Their matter, consisting of different materials, is variously formed. The forming of it happens by demarcation as setting up an inclosing and excluding border. Herewith, space comes into play. Becoming occupied by the sculptured structure, space receives its special character as closed, breached and empty volume. A familiar state of affairs, yet puzzling.

HEIDEGGER, "Art and Space"[27]

Which leads me to the final section of these reflections on the role of images and media in the revolutionary events of 2011, and the question of aesthetics. What role did the arts play in Tahrir Square and Zuccotti Park, and in the spaces between and beyond them? I want to restrict these reflections to the visual arts, even though it is clear that song, and especially rap music, probably played a crucial role in maintaining the spirits of the crowds gathered by and into the physical spaces of occupation by the media. At the same time, I would like to expand beyond the works of art that were produced during this year to consider in a more general way how public space is "becoming occupied," as Heidegger puts it, "by the sculptured structure," with sculpture considered, however, in the "expanded field" of countermonumentality, installation, site specificity, and performance.[28]

I have been talking as if the occupation of public spaces by mass assemblies is itself an artistic practice. But how seriously should we take this claim? Is it right to claim, for instance, that Martin Luther King Jr. was a performance artist in his masterful staging of marches, sit-ins, and mass rallies? Or is this really just a whimsical comparison—one that minimizes the serious

political purposes of the civil rights movement, in which the arts were merely a handmaiden, an instrument, or a servant of the cause? Isn't the aestheticizing of politics, as Walter Benjamin warned, the broad highway to fascism, as instanced by the films of Leni Riefenstahl and the mass spectacles of Albert Speer, while the straight and narrow road to social progress and communism is the "politicizing of art?" The twentieth century, and modernist forms of public art, showed us the convergence of these alternatives in the Nuremberg rallies and the mass gatherings designed to celebrate state power and militarism in the Soviet Union and China. This suggests to me that we need a better account of the relation of aesthetics and politics than Benjamin's fatal choice between fascism and communism.

Siegfried Kracauer's reflections on the role of what he called "mass ornament" suggest that the viable "third way" is most certainly *not* to be found in capitalism, which occupies public spaces with advertising (as in Times Square), or privatizes the agora and the village square by transforming it into the space of the shopping mall. (It is okay, of course, for the masses to camp out in front of WalMart in order to grab the bargains available to the first customers). For Kracauer, the "structure of the mass ornament" epitomized by the geometric pattern dances of the Tiller Girls "reflects that of the entire contemporary situation" in its reduction of the human body to a cog in an abstract machine known as capital.[29] Yet Kracauer concedes that "the aesthetic pleasure gained from ornamental mass movements is *legitimate*" (79) because it actually reveals a truth about capitalism, as did the Nuremberg rallies with respect to fascism: "When significant components of reality become invisible in our world, art must make do with what is left."[30] The Occupy Movement "made do" with an outpouring of spectacle and statements, viral words, and the gathering of images, faces, and crowds.

But there is a further question for the arts more generally. How has adventurous, progressive public art in our time produced significant reflections on the spaces that it occupies?

What might we learn, specifically, from the history of public sculpture in our time? Michael North's 1990 essay "The Public as Sculpture" offers an opening into this question.[31] Written precisely at the peak of the postmodern turn in public art toward questions of site specificity, performance, and public participation, and coinciding with the end of the Cold War and the events of Tiananmen Square, North's essay provides an incisive account of the transformation of public and politically engaged art that still resonates today.[32]

Departing from Rosalind Krauss's observation that "surprising things have come to be called sculpture" in the late twentieth century, North documents the genealogy of the twin metaphors of the public as sculpture and as architecture. In the most reductive and abstract form of the public literally manifested as both sculpture and architecture, a canonical example would be the obelisk of the Washington Monument, regarded "not as a monolith but a composite of many individual blocks," corresponding to the incorporation of individual citizens into a totality: "E pluribus unum." The Washington Monument is thus a kind of abstract version of Hobbes's Leviathan, incorporating all individual citizens (reduced to identical blocks) into one gigantic form symbolizing the first occupier of the empty place of sovereignty. At the other extreme would be "the great empty space" in which, as Eric Hobsbawm noted, "the emphasis shifted from statuary" to "spaces in which massed crowds were to provide the aesthetic impact." (17) But the masses that occupy these empty spaces are generally there to stage the miracle (sometimes a product of democracy, sometimes of violence) by which the many become one, and they are thus oriented around the central figure of the leader, the representative, the one who speaks for and to the many.

But other alternatives for public art exist. North focuses particularly on the practices of Joseph Beuys, who, "rather than erecting monuments, seriously intended to make the people into a monument, a social work of art, one that would be con-

structed by each individual as 'a sculptor or architect of the social organism.'" (14) The result, in Beuys's view, was to be the "TOTAL ARTWORK OF THE FUTURE SOCIAL ORDER." North expresses some measured skepticism about the totalizing character of this program, suggesting that "when Beuys called his work 'social sculpture' or 'social architecture,' he perhaps should have trembled at the complexity of the historical and political background thus evoked," (17) particularly in totalitarian deployments of the masses as ornament to the sovereign. He suggests that the statue of the "Goddess of Democracy" in Tiananmen Square "may have signified . . . the rebellion of the crowd against its own service as human sculpture in the square. The question facing artists like Beuys is how to keep the communitarian hopes and the revolutionary implications of the metaphor of social sculpture alive when the autocratic possibilities of this metaphor are so painfully realized." (17)

No work of art, by itself, could be expected to answer this question. But there have been a few attempts to "make do" that might be useful in thinking through the problem of public art and the occupation of public space in our time, particularly in terms of the task of mediating the individual and the collective. One artist who has reflected consistently on this dialectic is Antony Gormley. His *Brick Man* (1987), for instance, is a kind of literalizing of the political and religious metaphor of the Leviathan or giant man who incorporates multiplicity into a single body (figure 1). If the human body, on the one hand, is a "temple," the community, on the other hand, is a "building," What could be more inevitable than the building of a body, a building shaped like a body? The constituent bricks are like cubic stones that Christian emblematics imagined as the building materials of the church itself. As George Wither puts it:

> *Lord*, let us into such like *Stones* be squar'd:
> Then, place us in thy spirituall *Temple*, so,
> That, into one firme *Structure*, we may grow

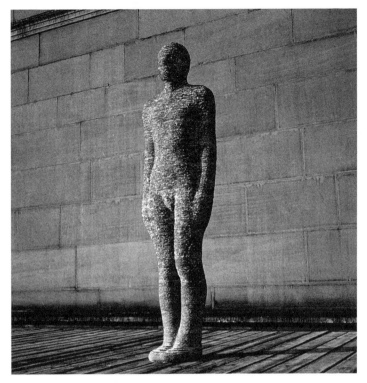

FIGURE 1. Antony Gormley, *The Brick Man* (model), 1987. Terra-cotta, fiberglass, plaster; 196 × 50 × 38 cm. Collection of Leeds City Art Gallery, Leeds, England. Copyright © by the artist.

He illustrates his point with a cubic form that is both the role of Jesus as cornerstone and the individual believer as a cubic unit that finds its proper place within the structure of the church.

Gormley's *Brick Man* functions, then, like Kracauer's geometric array of female bodies in the cinema of mass ornament: it is "legitimate" in its inevitability and accuracy as an expression of the whole religious discourse of sovereignty and collective unity. At the same time, Gormley has created works that separate the individual and the collective in striking ways, producing sentinels or "witness figures" cast from his own body that may appear anywhere: as lone figures on a beach, as watch-

ers stationed atop office buildings, as homeless and displaced forms in nondescript urban spaces, or as abject figures abasing themselves before the massive facades of architectural monuments—almost anywhere, in short, *except* in the monumental position of the statue on a pedestal in a public space. In other words, they occupy space in a manner directly antithetical to that of the public monument. Or, in the case of a work like *Quantum Cloud*, the tallest piece of sculpture in London, they deconstruct themselves, seeming to explode like a cloud of structural beams that are flying apart. They also deconstruct the fundamental tension between the mass and the individual in the public monument. Each figure is cast from the artist's individual body, but the figures are also duplicated indefinitely in a homogeneous series, like three-dimensional sculpted photographs or "corpographs." In a work like *Another Place* (first exhibited on the beach of Cuxhaven, Germany, in 1997), therefore, in which the figures seem to be vanishing into a tidal plain, they evoke both the solitary singularity of a work like Caspar David Friedrich's *Monk by the Sea* (1808–10) while at the same time suggesting a mass migration of identical figures toward an indefinite horizon.

When Gormley was invited to address a traditional monumental location for public sculpture, the empty Fourth Plinth in Trafalgar Square, originally erected to support a never-installed statue of King William IV, he did not fabricate any objects, but instead staged a six-month-long performance in which anyone could apply to occupy—stand, sit, or act atop—the plinth for one hour on a 24/7 schedule.[33] Actors, musicians, activists, strippers, poets, mystics, jugglers, scholars, cranks, and exhibitionists filled out the schedule with round-the-clock performances, occupying the place of the sovereign monument with the living bodies of individuals from every corner of the globe.

But perhaps the most profound sculptural meditation on the whole cluster of issues surrounding the occupation of public space, the mass assembly, and the individual body is Gormley's

Field: a mass gathering of terra cotta figures, each fabricated by a different individual. This work, which since 1991 has been installed in several locations around the globe, involves the participation of specific communities (Mexican bricklayers, Chinese workers) whose members each mold a handheld-size clay figure to be gathered into a single "mass ornament." In a process very much like children's first experiences with modeling clay, they bring their figures to life by punching eye holes in them. Gormley then fires the clay figures and assembles them in interior spaces. In the Guangzhou version of this work, two hundred thousand "body surrogates" of this sort were modeled from 125 tons of clay (figure 2). They "completely occupy the space in which they are installed," creating the impression of what Gaston Bachelard called an "intimate immensity," a vast crowd of miniature humanoid figures all facing the beholder. "The viewer," Gormley notes, "then mediates between the occupied and the unoccupied areas of a given building," so that "the physical area occupied" is "put at the service of the imaginative space of the witness."[34]

In the political and formal terms we have been exploring in relation to the sculpture and occupation of public space, *Field* absolutely renounces any hierarchical structure, instead presenting a spectacle of thousands of minutely differentiated individual figures assembled in what looks like a homogeneous crowd, a "sea of humanity" (or a "field" like the Champ de Mars). The effect is to turn the tables on the spectator, making her the "looked at," the object of the artwork's gaze. With a quarter million faces looking at you, what do you feel? One answer is, of course, that you feel overwhelmed at the sublime immensity of the mass gathering, like Friedrich's monk by the sea experiencing his own minute scale in the presence of infinitely empty space and the power of the multitude. But a moment's reflection switches the aspect utterly and one now experiences her own body in a Gulliverian scale: as gigantic in proportion to the miniature figures. And beyond that, one senses a kind of expansive-

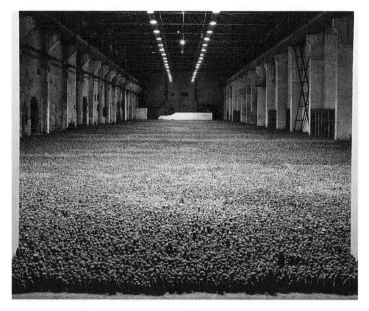

FIGURE 2. Antony Gormley, *Asian Field*, 2003. Clay from Guangdong Province, China. The piece includes 210,000 hand-sized clay elements made in collaboration with 350 people of all ages from Xiangshan village, northeast of the city of Guangzhou in southern China. Installation view, warehouse of Former Shanghai No. 10 Steelworks, Shanghai, 2003. Photograph by Dai Wei, Shanghai. Copyright by the artist.

ness, as if one were occupying the empty space of sovereignty at the critical ceremonial moment (an inauguration or coronation), preparing to address the assembled masses.

Gormley's playful *detournements* of public space and their relation to individual and collective bodies do not exist in a vacuum, of course. As Michael North argues, in the last quarter century, in moments punctuated by a host of critical and antimonumental works of public art, from the Vietnam Veterans Memorial to the Goddess of Democracy to Richard Serra's *Tilted Arc*, artists have been experimenting with new ways to occupy the public space, and to free that space from its obsession with monumental representations of sovereignty and the exploitation of the masses as ornaments of state power.

Gormley's work rarely engages the explicitly political tactics of the occupation of public space as aspects of a protest movement. For a marvelous reflection on the more directly political work of occupation, I turn to Mark Wallinger's *State Britain*, installed at the Tate Britain in 2007. Wallinger and his team assembled handmade reproductions of all the protest posters displayed in an antiwar encampment that occupied Parliament Square from the beginning of Britain's involvement in the economic sanctions on Iraq. The protest had been initiated by an activist named Brian Haw, who set up his camp in the square in June 2001 and remained there, surviving with the support of other activists for ten years. So far as I know, Haw engaged in the longest "occupy" movement in the history of political protest. If there is a Guinness world record for nonviolent political occupations, he must hold it.

But Parliament, under the leadership of Tony Blair, found the constant presence of Haw's occupation annoying. It became especially problematic when Haw was joined by other artists and activists, expanding the encampment and its panorama of protest posters across one whole side of the square. So Parliament passed the Serious Organised Crime and Police Act 2005, which authorized the police to prohibit any political demonstrations conducted without a permit within *one kilometer* of the Houses of Parliament. The act further specified that the police were authorized to prohibit not only mass demonstrations, but demonstrations "carried on by a person by himself." In other words, a person who wished to wear a T-shirt with an antiwar slogan, or a slur against "Toady" Blair or his lackeys in Parliament, would be required to give the police seven days' notice of his intention to carry on a demonstration in the "designated area" within a kilometer of Parliament (figure 3).

Armed with this ordinance, the police swept into Parliament Square in May 2006 and removed most of the encampment along with the posters. But they were not able to remove Brian Haw. Since his occupation of the square had begun before the

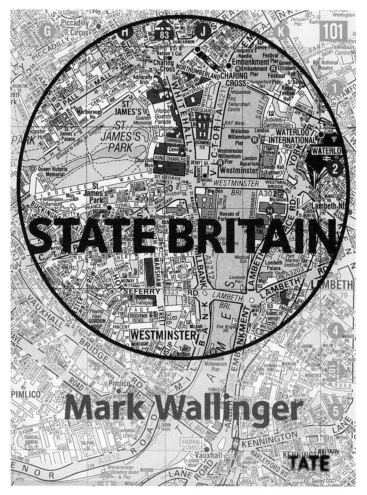

FIGURE 3. Mark Wallinger, *State Britain*. Cover of Tate Publishing paperback. Copyright Tate, 2007. Courtesy Anthony Reynolds Gallery, London.

law was passed, he was grandfathered in as a legal exception, as long as he maintained a continuous occupation of the public space. His occupation continued until (appropriately enough) the Arab Spring of 2011, when London Lord Mayor Boris Johnson brought a legal action to have him removed. The British High Court ruled that "Parliament Square Gardens is not a suit-

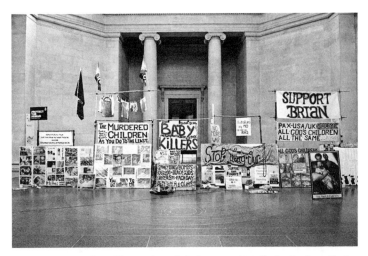

FIGURE 4. Mark Wallinger, *State Britain*, 2007. Detail of mixed media installation. Approx. 570 cm × 190 cm × 43 m. Tate Britain, 2007. Copyright by the artist. Courtesy Anthony Reynolds Gallery, London. Photograph by Dave Morgan.

able location for prolonged camping," and ordered that he be removed before the royal wedding, which no doubt would have been embarrassed by his continued presence.[35]

The images of Haw's occupation, however, will be preserved as long as there is an England. Mark Wallinger's reenactment and reinstallation of the protest posters will be preserved in the archives (figure 4). And when reinstalled, it will no doubt include the most salient feature of the original site-specific installation in the Tate Britain. It turns out that the great hall at the center of Tate Britain straddles the boundary line of one kilometer measured out by Parliament's "Serious Organized Crime and Police Act." This legal boundary, marked by a line of black tape on the floor of the museum's great hall, was crossed by Wallinger's installation. It was an act of civil disobedience, but one that, in my view, produced a rather melancholy affect, as if the simplest act of political protest or public demonstration, let alone an aggressive but nonviolent occupation of public space, has now been removed to a safe and sanitized location: the sanc-

tuary of the aesthetic space. It is as if the public's right to free assembly and speech, a foundational principle of British liberty and of democracy everywhere, has now been anesthesized or fossilized, consigning the fundamental freedoms to a state of suspended animation, or to inert relics of a time when the ringing of a Liberty Bell might have actually meant something.

As critic Adrian Searle noted at the time, Wallinger's *State Britain* was not some isolated instance. [36] The "40-metre-long wall of banners, placards, rickety, knocked-together information boards, handmade signs and satirical slogans" not only included work by graffiti artist Banksy, but "reminds one of ... the installations of Mike Kelley [and] the placards, swathes of photocopied material and detritus of Thomas Hirschorn," to which one could add the performance pieces of Tania Bruguera, the installations of Hans Haacke, and the crowd-sourced art works of Occupy Wall Street. "Most of all," notes ethnographer Michael Taussig, "I was struck by the statuesque quality of many of the people holding up their handmade signs, like centaurs, half person, half sign."[37] The Occupy Movement of 2011, from Tahrir Square to Zuccotti Park and beyond, has, perhaps without knowing it, employed the arts of occupation in all their manifestations. Phalanxes of posters, mass gatherings, lone individuals facing massive police lines, momentary performances and enduring tent cities, parades and encampments, festivals and confrontations have all been united by an ethic of nonhierarchy and nonsovereignty, deconstructing both the sovereignty of the politician and that of the artist.

On the other hand, there is Michelet's haunting image of empty space itself as the truest monument to revolution. Could this be because so many revolutions leave nothing behind? That in some fundamental sense they cannot be realized perfectly, and are often terrible failures, as the long Arab Winter of "revolutionary" military dictatorships shows us? The notable success of the American Revolution, according to Hannah Arendt, was in its rapid movement toward a "constitutive" moment, the

laying of foundations, the framing of a constitution, the pro-
duction of an architectural structure, and the reproduction of
a living document.[38] The state, as Eric Slauter has shown, was
to be constructed as "a work of art"—principally the art of ar-
chitecture, not the sculptural figure of the sovereign "body
politic."[39] Of course, the phallic image of the state would soon
follow, and merge with architecture. It is to be seen in the erect
body atop the empty plinth, the figure of sovereignty that links
monarchy, sacred icons, and the archetype of the "Founding
Fathers," and is epitomized most dramatically, as we have seen,
by the obelisk of the Washington Monument. Not accidentally,
the effect of this monument is inseparable from its dialogue
with empty space, including the virtual space produced by the
reflecting pool. Nor, of course, is it an accident that this is the
principal site of the national exercise of the First Amendment,
the right to peacefully assemble, and now to Occupy. Perhaps
empty space is the only true monument not just to revolution,
but (as Jacques Derrida would have insisted) to the potential of
a democracy and a new global constitution to come.

NOTES

1. I am grateful to Shereen Aboueinaga of Cairo University,
Shaker Abdel Hamid, head of Egypt's Supreme Council of Culture,
and Omar Berrada, director of the research library at Dar al-
Ma'mun for these generous invitations.

2. Hannah Arendt, *On Revolution* (New York: Penguin Books,
1963), 18. For the Bernard Harcourt epigraph, see essay in this
volume.

3. As Arendt puts it in contrasting the French and American
revolutions, "The reason for success and failure was that the pre-
dicament of poverty was absent from the American scene [for white
European settlers, that is] but present everywhere else." Arendt
goes on to qualify this by noting that it is a relative question: "The

laborious in America were poor but not miserable," in contrast to those living in European conditions. The other crucial difference between France and America was the presence of local colonial governments and participatory democracy. Alongside this, as Arendt notes, was "the institution of slavery," which "carries an obscurity even blacker than the obscurity of poverty." *On Revolution*, 58–60.

4. Ariella Azoulay, "The Language of Revolution: Tidings from the East," *Critical Inquiry*, Fall 2011. http://criticalinquiry.uchicago. edu/the_language_of_revolution_azoulay. Accessed April 17, 2012.

5. Slavoj Žižek, *The Ticklish Subject* (New York: Verso, 2nd edition, 2009). The full quotation is: "It is only right-wing populism which today displays the authentic *political* passion of accepting the *struggle*, of openly admitting that, precisely insofar as one claims to speak from a universal standpoint, one does not aim to please everybody, but is ready to introduce a *division* of 'Us' versus 'Them'" (210).

6. See also the broadcast of Canadian World News shortly after bin Laden's assassination, in which the anchorwoman repeatedly called the dead terrorist "Obama."

7. We should not forget here the most famous "soft" revolutions in the last twenty-five years: the "Velvet Revolutions" that occurred in Eastern Europe during the fall of the Soviet Union. They, too, were especially susceptible to being (a) subject to flights of fantasy and exaggerated images, and (b) disappointing to authentically radical revolutionaries. See my essay "Revolution and Your Wardrobe: Fashion and Politics in the Photography of Jane Stravs," assessing the role of fashion photography in the sensibility that led up to the Slovenian Revolution. (Ljublana: Scientific Research Centre of the Slovenian Academy of Science and Arts, 2002), 79–82.

8. Fawkes is the legendary leader of a Catholic resistance movement that attempted to blow up the Houses of Parliament in 1605. He was transformed into a positive secular hero by the 1980s graphic novel, *V for Vendetta*, which was adapted for a film of the same title by the Wachowoski brothers in 2006.

9. See H. A. Kelly, "*Occupatio* as Negative Narration: A Mistake

for Occultatio/Praeteritio," *Modern Philology* 74:3 (February 1977). Kelly traces the trope to Quintilian, who regarded it as "a rhetorical figure by which an opponent's objections are anticipated and answered," and to the Greek *paraleipsis*, "a figure by which summary mention is made of a thing, in professing to omit it."

10. For a meditation on the place of violence in public spaces, see my essay "The Violence of Public Art: *Do the Right Thing*" in *Art and the Public Sphere*, ed. W. J. T. Mitchell (Chicago: University of Chicago Press, 1990).

11. Arendt, *The Human Condition* (Chicago: University of Chicago Press, 1958), 199.

12. See Arendt, *On Revolution*, on the revolution as "new beginning" (19).

13. In the person of Brian Haw, whose record-setting occupation will be the subject of the final section of this essay.

14. See Harriet Sherwood, *The Guardian*, August 4, 2011. Accessed at http://www.guardian.co.uk/world/2011/aug/04/tel-aviv-tent-city-protesters. See also Ariella Azoulay, *Critical Inquiry*, Fall 2011.

15. See Michael Taussig,"I'm So Angry I Made a Sign," this volume: his ethnographic account as a witness and participant in an overnight campout in Zuccotti Park. Also Barry Schwabsky, "Signs of Protest: Occupy's Guerilla Semiotics," *The Nation*, December 14, 2011.

16. I owe the idea of Martin Luther King Jr. as a performance artist to Bill Ayers.

17. I am informed by correspondents that the blue brassiere has become the hottest fashion item in Cairo boutiques.

18. Preface to *History of the French Revolution* (1847), trans. Charles Coeks (London, 1847–48).

19. Hazlitt, *The Life of Napoleon*, 1828, 1830; *Collected Works*, ed. P. P. Howe, 21 vols. (London: J.M. Dent & Sons, 1931), 13:38. Carlyle, *The French Revolution* (1837; New York, 1859), 28–29.

20. See Russ Castronovo's comparative study of Benjamin Franklin's leakage of inflammatory correspondence between

the Crown and the American colonial administrators, and the phenomenon of Wikileaks and Julian Assange. *Critical Inquiry*, forthcoming.

21. Naomi Klein, "The Shocking Truth about the Crackdown on Occupy," *Guardian*, November 25, 2011. Accessed April 14, 2011, at http://www.guardian.co.uk/commentisfree/cifamerica/2011/nov/25/shocking-truth-about-crackdown-occupy.

22. Rabbat, "Circling the Square," *Artforum*, April 2011, 182–91.

23. *Welcome to the Desert of the Real*, 151. Cited in Jodi Dean, "Žižek against Democracy," 5.

24. Žižek distinguishes between Hitler and Stalin in an elaboration of the castration metaphor. Hitler only *seems* to have balls: "All his actions were fundamentally reactions: he acted so that nothing would really change . . . to prevent the communist threat of real change." Stalin, by contrast, was "truly daring," and did have balls. It was of course regrettable that his ruthless violence caused "suffering beyond comprehension," but the real problem was that the violence was motivated by "blind rage and panic" (as opposed, one presumes, to cold, clear-eyed calculation) and wound up devouring itself in purges of "high party echelons." *Violence* (London: Profile Books, 2008), 177–78.

25. "Slavoj Žižek at Occupy Wall Street," original text posted by Sarah Shin, October 10, 2011, on Verso Blog: http://www.versobooks.com/blogs?post_author=16.

26. See Mark Greif's very thoughtful essay, "Drumming in Circles," *Occupy: Scenes from Occupied America* (New York: Verso, 2011), 55–62.

27. "Die Kunst und der Raum," Erker Verlag, St. Gallen, 1969. Trans. Charles H. Seibert, in completion of his doctoral dissertation, "On Being and Space in Heidegger's Thinking."

28. See Rosalind Krauss, "Sculpture in the Expanded Field," *October*, vol. 8 (Spring, 1979), 30–44, and James V. Young, "The Counter-Monument: Memory against Itself in Germany Today," *Critical Inquiry*, 18:2 (Winter 1992), 267–96.

29. Kracauer, "The Mass Ornament" (1963), in *The Mass Orna-*

ment: Weimar Essays, trans. Thomas Levin (Cambridge, MA: Harvard University Press, 1995), 78.

30. See also Elias Canetti, *Crowds and Power* (1961); Gustave Le Bon, *The Crowd*; and, for a critique of the usual dismissal of crowd psychology as a form of madness and irrationality, Ernesto Laclau, *On Populist Reason*.

31. In *Art and the Public Sphere*, ed. W. J. T. Mitchell (Chicago: University of Chicago Press, 1990), 9–28.

32. See Barry Schwabsky, op. cit., for a discussion of the signs at OWS; also Michael Taussig, op. cit., on the statuesque character of the sign bearers.

33. For an interesting companion piece in the Trafalgar Square series, see Yinka Shonibare's wonderful "ship in a bottle," a scale model of Lord Nelson's flagship festooned with sails made from West African fabrics. If Gormley is engaged in a democratization of the monumental site of sovereignty, Shonibare is attempting to bring the iconography of British imperialism home to its proper site: Trafalgar Square, named after Nelson's greatest victory.

34. Text from Gormley's website: http://www.antonygormley. com/sculpture/item-view/id/245.

35. See Mark Hughes, "Brian Haw Loses Battle against Parliament Square Eviction," *The Telegraph*, March 17, 2011. Accessed at http://www.telegraph.co.uk/news/uknews/royal-wedding/8388000/Brian-Haw-loses-battle-against-Parliament-Square-eviction.html.

36. Searle, "Bears against Bombs," *The Guardian*, January 15, 2007. Accessed at http://www.guardian.co.uk/world/2007/jan/16/humanrights.politicsandthearts.

37. Taussig, "I.".

38. See *On Revolution*, op. cit., 117.

39. Slauter, *The State as a Work of Art* (Chicago: University of Chicago Press, 2009).